THE FIRST PHOTOGRAPHY BOOK

Peter Smith

Conceived, edited and designed by Xanadu Books Ltd.,
5 Upper Church Street, Douglas, Isle of Man, via Great
Britain
© 1987 Xanadu Books Ltd. Written by
Paul Wilkinson.
Typeset by Input Typesetting Ltd, London
Printed in Great Britain by R. J. Acford Ltd,
Chichester, Sussex

Published in Great Britain by Guinness Superlatives Ltd,
33 London Road, Enfield, Middlesex

'Guinness' is a registered trade mark of
Guinness Superlatives Ltd

British Library Cataloguing in Publication Data

Peter Smith
 The first photography book.
 1. Photography—Juvenile literature
 I. Title II. Wilkinson, Paul
 770'.28 TR149
 ISBN 0–85112–846–7

Contents

Using the camera

What is a camera?

A camera is basically a box with a piece of light sensitive film at one end and a hole at the other. The hole is there so that light can enter the box, shine on the light sensitive surface of the film and make a picture. Every camera, from the pinhole to the most sophisticated, which has been to the moon and back, works on the same principle. The only difference is how well and how easily they do the job of directing light onto the film to make a picture.

To do this easily certain things are necessary (*see* drawing below). There must be a means of aiming the camera at what you want to photograph (viewfinder). There must be a way of controlling the amount of light entering the camera (diaphragm) because, for example, on sunny days there is more light entering than on a cloudy day. There must be a way of cutting off the light entering the camera (shutter), otherwise the film would collect too much light.

There must be a lens to collect and focus the light (or image) onto the film and also a focusing device to move the lens back and forth so that the image projected onto the film stays sharp. All cameras have these controls; some have more so that specialist tasks can be done, i.e. the camera which takes the school photograph is designed to swing from left to right over an arc so that all six hundred pupils can be captured on film at the same time.

Light source

Photography means writing with light. Light means the sun, electric light and candles. Light travels outwards in straight lines and in all directions from its source. When light hits an object it is reflected again in straight lines and when the reflected light enters our eyes (or the camera lens) we see the object. To understand this, think of the moon: it has no light source of its own, and when we see it we are seeing light reflected from the moon but which came originally from the sun.

Lens

A lens is a disk of glass, ground and polished until it is thinner at the edges than at the centre. The lens collects all the light and converges it to a single focal point. This creates a reversed, upside-down image on the film at the back of the camera.

Shutter

The shutter is the second light control in a camera. It allows you to choose the exact moment to take the picture. It also controls the amount of light allowed to enter and register on the film. An exposure of only a fraction of a second is sufficient except on a very dull day.

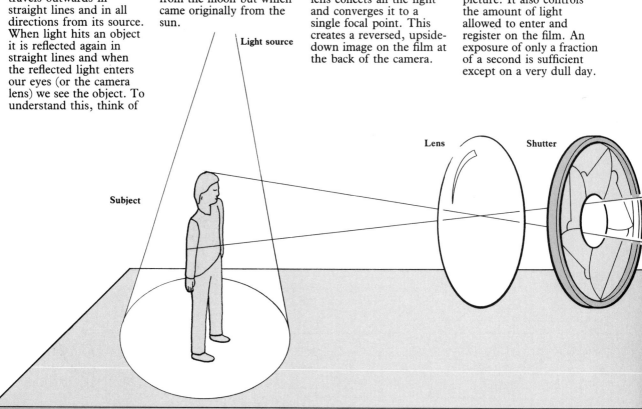

Light source

Lens

Shutter

Subject

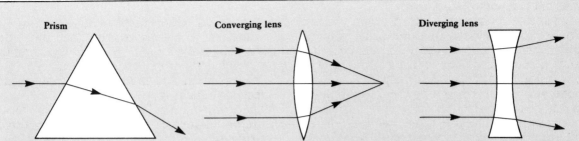

Prism **Converging lens** **Diverging lens**

How a lens works
Lenses work on the principle of refraction: the speed at which light passes through the air is constant, but when it passes through another medium light is slowed down and this causes the light rays to be bent or refracted. A simple way of understanding this is to fill a glass with water and put a pencil into it: the straight pencil appears to be bent.

The lens used in a camera is usually some form of converging lens. A converging lens acts like a series of prisms. Light is bent more on the circumference and least at the centre. This in effect concentrates the light on a point of focus (focal plane). The distance from the lens to the focal plane is called the focal length, so if your camera has a 50mm lens (look on the edge of the lens to find out) it means the distance from the lens to the point of focus is 50mm. This is the same measurement as the diagonal of the picture area. This will give a normal looking picture. A diverging lens disperses light. It cannot form an image on film, but it is used in the direct vision viewfinder, where the human eye will see a miniature upright image of whatever the camera is focused on.

Diaphragm
The diaphragm is the third light control. It forms an adjustable hole (aperture) whose function is very similar to that of the iris in the human eye. By varying its diameter you can control the amount of light entering the camera.

Viewing System
The viewfinder shows the scene the picture is about to take, usually through a diverging lens (direct vision) or through the picture-taking lens itself (single lens reflex).

Focal plane and film
The focal plane is the surface on which the image is formed. Stretched over this flat surface is the film, which receives the light from the object being photographed and records the image on its light sensitive surface. The film advance winds the film forward from one spool to another inside the camera, using film roll or cartridge.

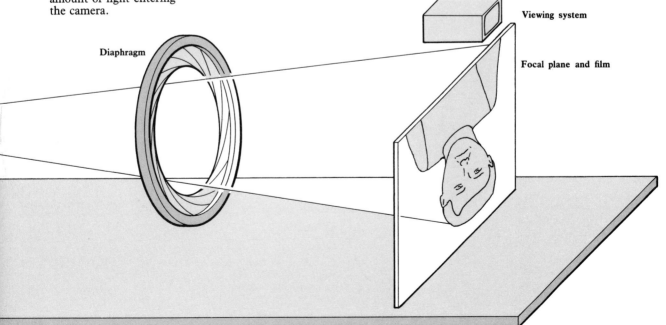

Diaphragm

Viewing system

Focal plane and film

Using the camera/2

110 and 126 pocket cameras.
Think very carefully before you decide which camera to buy. Don't let price be your only consideration. If possible, decide what you will be using your camera for. The 110 and 126 pocket cameras, for instance, do not allow you to develop your own negatives—instead, you must take them into the photo shop. Nor is it possible to change the lens or add other accessories. On the other hand these cameras do have the advantage of being small – you can keep them in your pocket—and they are loaded with negative film in a cartridge which is very easy to use. These cameras are easy to operate because the controls are simpler. They are capable of taking most of the pictures you will want to take and the results will not be any better or worse than those from a more expensive camera.

The limits are (and it is worth keeping them in mind): you will only be able to take pictures which relate to the weather symbols; you cannot photograph fast moving objects because there are no fast shutter speeds; you cannot take close-up photographs because it is not possible to fit a close-up lens. Some 110 cameras have a second lens, which will enlarge the image by 50 to 60 per cent.

Film
The 110 camera uses film 16mm wide on which it produces negatives 17×13mm. The 126 camera uses a larger cartridge and produces square negatives 28×28mm. Both sizes have to be processed professionally.

Lens
Most cameras of this type have a fixed focus lens, which means that, owing to the short focal length and small aperture, everything photographed from a distance of 1.5 meters will be in focus.

Choice of film
Choice of film will be limited. Black and white, negative and colour transparency film is available in speeds suitable for most applications, although obtaining a fast film is a problem.

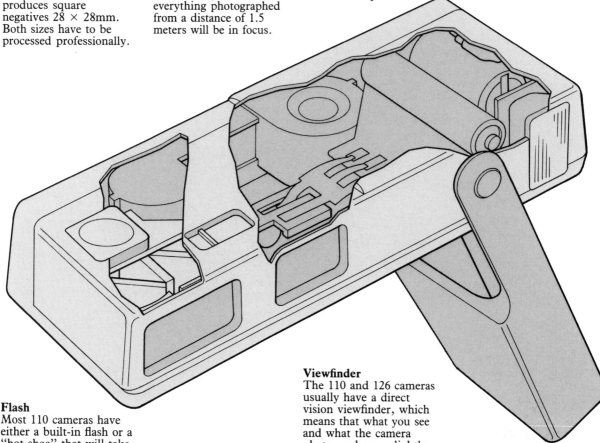

Flash
Most 110 cameras have either a built-in flash or a "hot shoe" that will take flash cubes. Some models have an add-on flash unit.

Viewfinder
The 110 and 126 cameras usually have a direct vision viewfinder, which means that what you see and what the camera photographs are slightly different at close distances (parallax error).

Simple direct vision.

This camera is usually smaller than the normal 35mm camera, and is so called because the viewfinder is separate from the picture-taking lens. The advantages of this camera are that you have a sharp, bright view of the subject and the camera controls are simple and straightforward to operate.

Most models have some form of automatic exposure control. The lens on this type of camera is of a much better quality than that on the 110 camera, the simplest type being a fixed focus lens which can handle a full length figure to a distant landscape.

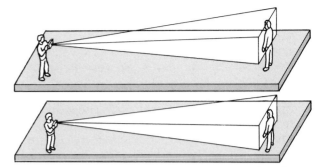

Film
These cameras will take 35mm cassettes of 20 or 36 exposures. They are not as easy to load as a 110 camera, so make sure you read your instruction book first.

Lens
Simple direct vision cameras have fixed-focus lenses, which means that anything from 6ft (2m) to infinity will be in focus.

Parallax error
The direct vision viewfinder cannot have exactly the same viewpoint as the camera lens. Although for landscapes the difference is negligible, in close-up the error becomes apparent.

When you start using the camera for close-up shots, you will find that more of the top and less of the bottom will show on the photograph. With practise you will be able to compensate for the error.

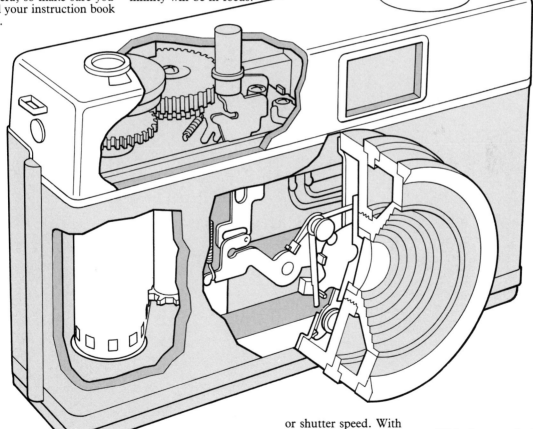

Exposure
Some cameras allow you to control exposure by setting either the aperture or shutter speed. With aperture priority, you select aperture and the camera will select the appropriate shutter speed.

With shutter priority you set the shutter and the camera sets the appropriate aperture.

Using the camera/3

The SLR (single-lens reflex) camera is one of the most highly developed and versatile cameras there is. With the wide range of lenses available you can turn your camera from a photographic microscope to a photographic telescope in a few moments by fitting the appropriate lenses. It is the most popular type amongst amateurs and professionals alike, and manufacturers tend to design their photographic accessories around the 35mm SLR camera.

The SLR is also the most electronically developed camera. Systems are improving all the time and 35mm SLR cameras have been developed to the extent that all you have to do is point the camera and press the button – the camera does the rest. Most single-lens reflexes accept 35mm film cassettes only (these are 1.5 inches wide). This film is the most economical to buy. You can make a large number of pictures at minimum expense, and with black and white film you are able to examine small, cheap prints with a magnifying glass before deciding which prints you want enlarged.

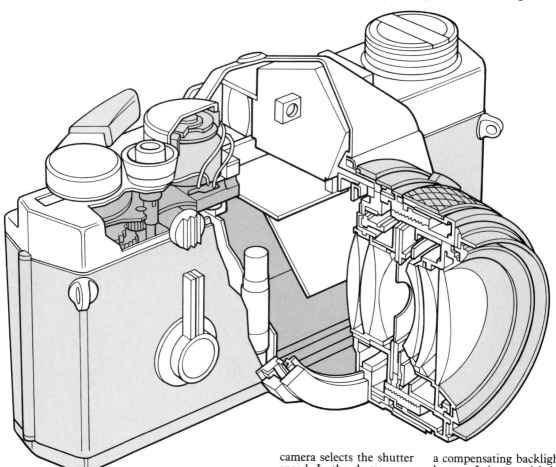

Viewfinder
The view seen through the viewfinder is the same as that seen by the taking lens. This type of viewing eliminates parallax error and is most useful when taking close-ups.

Automatic setting
Most SLR cameras have a built-in exposure meter which will indicate the amount of light and leave you to adjust the shutter and aperture accordingly. The aperture preferred system means that you select the aperture and the camera selects the shutter speed. In the shutter-preferred system you set the shutter speed but aperture is chosen by the camera.

The 35mm SLR has a number of other useful devices to aid the photographer. These range from a self-timer for delayed action setting to a compensating backlight button. It is essential that you read your camera manual thoroughly before using your camera. Make sure you know exactly what everything is for and how it works, and never, ever force any lever or button – always check back to the camera manual.

Supporting the camera
The longer the exposure time of a shot, the greater the risk of "camera shake" and consequently a blurred photograph. It depends on the way in which a camera is held, but the general rule is that 1/30 second is the longest exposure you can have without some form of camera support. Heavy telephoto lenses produce more shake because they are longer and heavier, so to avoid shake, longer lenses have a faster shutter speed.

The best type of camera support is the tripod. Make sure you buy one from the middle of the range, not so light as to be flimsy and wobbly and not so heavy that it is exhausting to carry. When using a tripod make sure the central leg is pointing forwards under the lens.

Make sure your elbows are resting against your chest in the normal horizontal position. Turn your head slightly and nestle the camera against your cheek, then breath in and hold your breath as you take the picture.

For a vertical-framed picture, make sure your elbows are resting against your chest, but use your forehead as a platform on which to rest the camera. Both these camera

positions produce better results if you can lean against a wall or tree, as this will help prevent your body swaying.

If you need to get lower and closer for a better photograph, use your knee as a tripod.

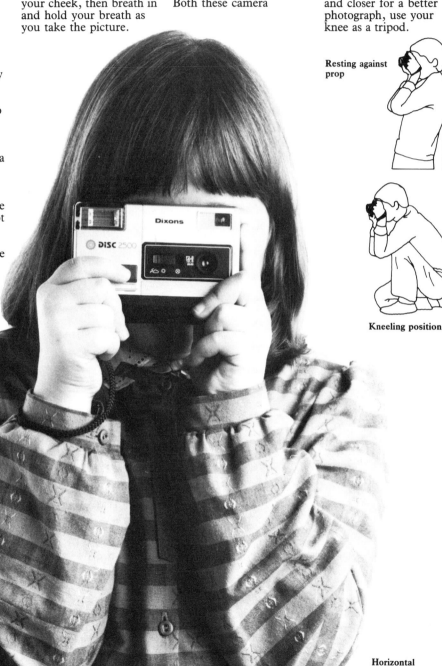

Resting against prop

Kneeling position

Horizontal

9

The camera kit

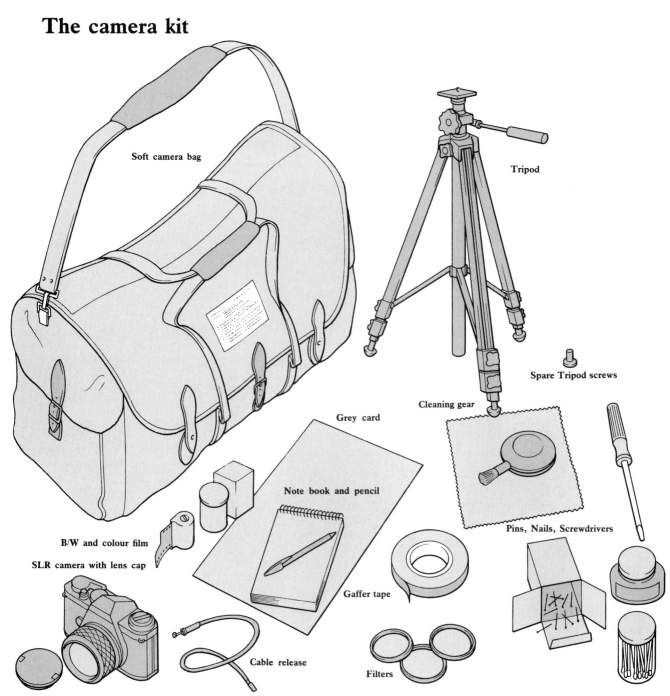

Soft camera bag

Tripod

Spare Tripod screws

Grey card

Cleaning gear

Note book and pencil

Pins, Nails, Screwdrivers

B/W and colour film

SLR camera with lens cap

Gaffer tape

Cable release

Filters

Camera kit
Apart from his camera and lenses a photographer needs a comprehensive tool kit which will either make or mar his photographs. If you are caught in a meadow taking a close-up photograph of a rare plant on a Sunday, you will need a reel of tape to hand in order to construct a windbreak, otherwise the plant will be dancing about in the wind and will appear blurred in your photograph.

Make sure you build up a selection of the smaller but essential photographic accessories. Their uses will be explained later on in the book. They are: lens hood; cable release; filters and holder; tripod and spare tripod screws (attaches camera to tripod); grey/white card for meter readings. Non-photographic accessories should include: pen and note book; gaffer tape; camera dust-off and cleaning cloth; drawing pins and screwdriver; clamps to hold down props; scissors and staple gun to hold things in place; a swiss army knife, which is almost a tool

Camera care

Care is essential if a camera and equipment are to last a long time. Camera service centres report that more than 50% of cameras brought in only need the battery changed, so read your camera manual!

The cleaning of all equipment should be carried out carefully using tissues and brushes specially bought for the purpose.

Use lens cleaner with a chamois cloth, rubbing very gently to remove any grease on the lens. It is better to protect the lens with a UV filter, but filters should never be cleaned. Use stiff brushes to dust off the camera before opening the back of the camera, then give the camera a final dust with the puffer "dust off". If in doubt about any aspect of cleaning, take the camera back to your dealer— *don't* undo any screws or nuts or fiddle with the inside.

Make sure your camera is serviced once a year, and not just before you go on holiday. Always use at least one roll of film before going away. It is always possible that the camera will come back from the photo shop in a worse condition than when it went away!

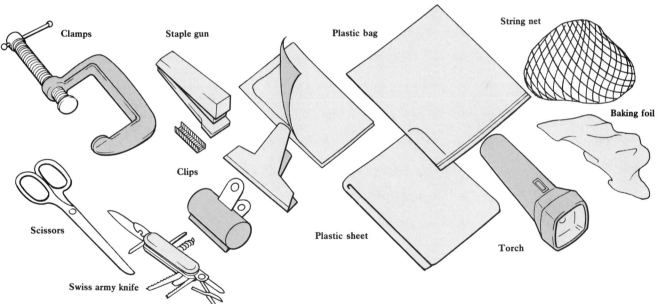

Clamps

Staple gun

Plastic bag

String net

Baking foil

Clips

Scissors

Plastic sheet

Torch

Swiss army knife

shop in its own right. A string bag can be filled with stones and used as a weight or slung from a tripod to steady it. A torch is useful if you run out of time and have to finish in the dark. Baking foil can be used as an outdoor reflector and a plastic bag

can be shaped around a camera, held around the lens with an elastic band. This will keep out the rain, sea spray or sand.

Protecting your camera
Always keep the camera in its camera case. Never leave it in the car in direct

sunlight, and if taking the camera to the beach keep it in a plastic bag. If you are going to a damp climate or sailing on a boat keep the camera in a plastic bag with a sachet of silica gel, obtainable from most camera shops. This will absorb most of

the moisture from the atmosphere. Use x-ray-proof bags when passing through security gates at airports. If going abroad make sure you buy sufficient film before you go, as you will find it expensive abroad.

11

1. **You will need** a small cardboard box (preferably black), scissors, black linen-backed sellotape and a piece of tinfoil. Cut one end of the box, make a light-proof lid to slide onto the box with at least 2in (50mm) overlap, and line this overlap with a strip of black velvet.

2. **Cut a small hole** in the other end of the box and cover it with tinfoil. Stretch the tinfoil until it is taut, then take a needle and make a very small hole in the tinfoil. Make a cardboard lens cap which can be positioned over the hole in the tinfoil.

3. **Sit in a darkroom** with a red safety light and tape a fast piece of film to the back of the lid. Replace the lid, then ask one of the family to sit for you in a chair. Arrange as many lights as possible to shine

onto your subject, rest the pinhole camera on a small table aimed at your subject and remove the lens cap for

two seconds. Develop in the normal way (*see* Darkroom). You will probably have to experiment with

timing and lights but the results will be worthwhile!

Using light indoors

Photography means "writing with light", and the two key elements of light are direction and quality. Although you could do this exercise with two anglepoise lamps, it would be best to obtain two photoflood tungsten lamps. For equipment like this always try the second-hand outlets – photography magazines or junk shops.

Lighting will transform the appearance and form of any subject. Before settling down to take photographs, try experimenting with the positioning of the lights—you will be amazed at the variety of shadows and surfaces that there are available.

Remember that the same principles apply when you take pictures outdoors. You will still be "writing with light".

For picture one, the light was positioned very low and to the right of the camera. See how all the surfaces in direct light have lost their detail. The opposite side is in deep shadow but some detail can still be seen.

For picture two, the light was positioned higher on the left. The details which were in shadow in picture one can now be seen. Also, the angle of light adds modelling to the roof

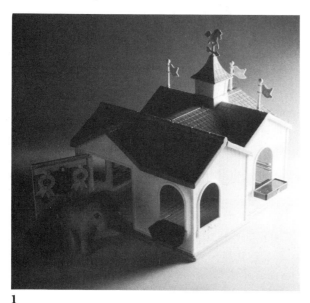

1

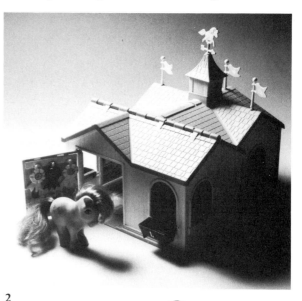

2

of the dolls' house.

For picture three, the light was positioned on the left, but a reflector (a sheet of white card) was used to reflect the light back on to the doll's house. Now both sides of the house are illuminated, all detailing can be seen and we are starting to get close to a good picture.

For picture four, the light was moved further round to the front. It is now possible to see inside the house, but the tiles on the roof have lost their modelling.

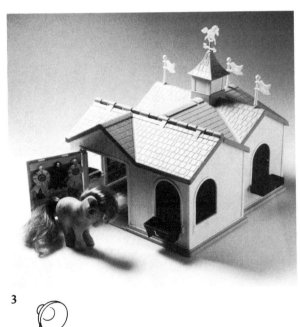

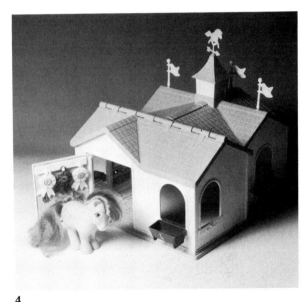

3

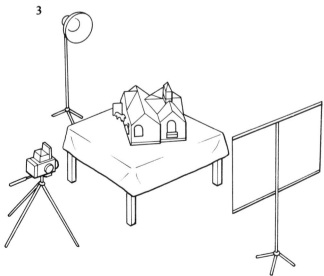

4

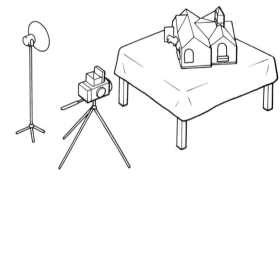

Using light indoors/2

Direct light

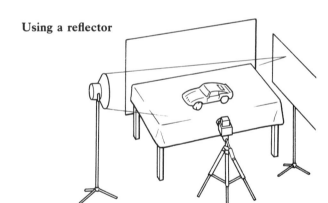

Using a reflector

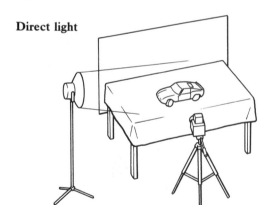

Bounced light

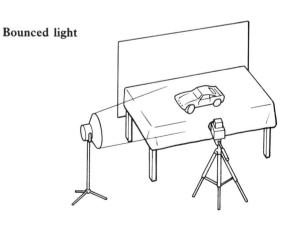

The rules of studio lighting are based on the principles of natural light as we see it outdoors. We are used to seeing buildings, people and landscapes illuminated by one light source (the sun) from above, rather than from below. Lighting should be used to enhance details and textures in the subject rather than mask them. Photographic film is less able to pick out details in shadow than the human eye, and this must be borne in mind when making final adjustments to lighting.

17

Using light indoors/3

Electronic flash is used to provide light indoors, and also outdoors on dull days. It works by batteries, so make sure you have spare ones. To use electronic flash on your 35mm SLR camera follow this simple procedure:

1. Position the flash on the "hot shoe" on the camera. If the bracket isn't connected to the camera, use the electric cord provided with the flash gun.

2. Set to 1/60 second on many automatic cameras.

3. On the back of the flash unit set the film speed (*see* Film) correctly on the film speed scale.

4. Turn on the flash unit and focus on the subject you want to photograph.

5. Take the picture when the red light shows, then rewind and wait for the red light to reappear.

6. Never leave the flash unit on, as this will rapidly drain the batteries. Check every month that the batteries are in good order and not leaking inside the flash unit. You will notice on inferior photographs of people that their eyes glow red; this is caused by the light reflection from the retina.

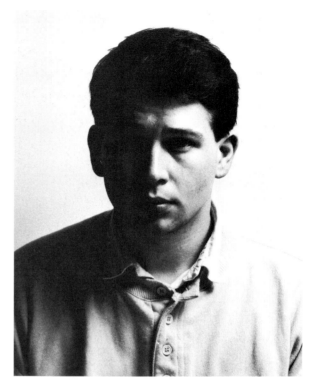

Diffused light

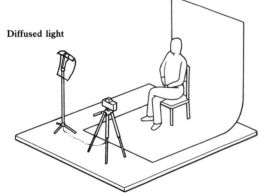

Diffused light
Try placing a sheet of tracing paper over the flash unit; this will scatter light and soften the rather harsh light of the flash unit. Shadows will be much softer and the light "fall off" is less apparent.

Bounced flash
Bounce the light from the flash unit off the ceiling or some other reflective surface. Aim the light at a point midway between yourself and the subject; do not bounce the light off coloured walls as this will tinge the photograph.

Fill-in flash
A portrait taken against a window will give an interesting effect, but the face will be in shadow as the exposure meter on the camera will have exposed for the overall picture.

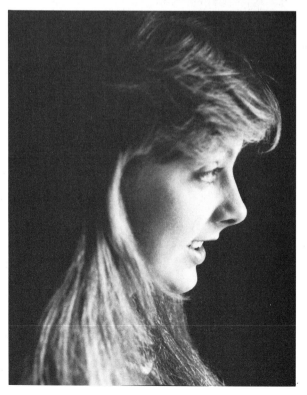

Photographing TV
The TV image is framed
by a scanning electronic
beam, so you must use a
shutter speed which is
slower than the time it
takes for the beam to
trace a complete image.
The television image is
retraced 30 times per
second (25 times in U.K.
625 lines). To photograph
the TV screen, the
camera must be slower
than this, ideally set at
1/8 or 1/15 second, so that
several complete images
can register on the camera
film.
 Don't forget to use a
tripod and cable release.

Use fast film
In bad light conditions, as
in this Egyptian tomb,
use a fast colour negative
film such as Kodacolour
VR 400 or 1000. These
will allow you to hand-
hold the camera in dim
light – they also give good

colour under tungsten and
fluorescent lighting
without using filters.

Candlelight
Candlelight is a very
difficult light source,
with low intensity and
extreme contrast. Use a
fast B/W film, a tripod
and cable release.

Using available light
If you are contemplating
using natural light on
interior location shots,
obtain the fastest B/W or
colour film you can,
certainly within 800/1000
ISO (ASA) (*see* Films).
Forget the tripod and
flash; hand-hold your
camera for shots you
never thought possible in
dim light.

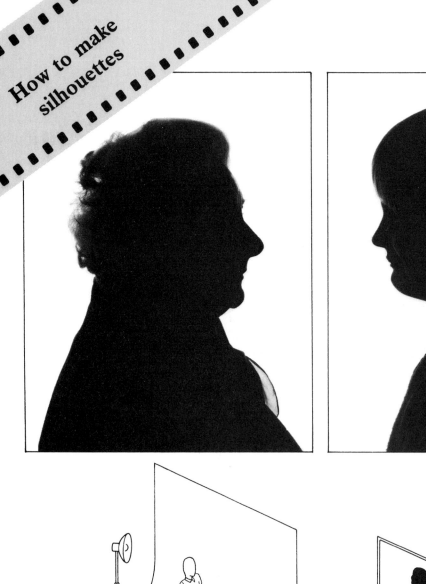

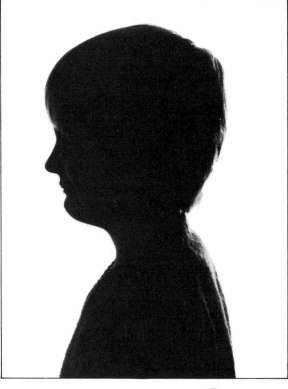

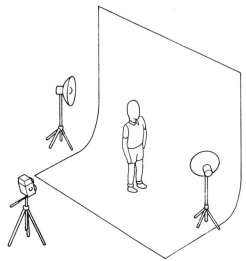

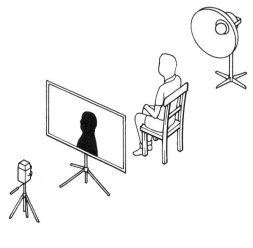

Lighting silhouettes
Silhouettes simplify; they emphasize a shape in terms of uniform dark and light; they are also fun to make.
The easiest way to photograph a silhouette is to position the subject, who is preferably wearing dark clothing, a few feet in front of a white backcloth, and illuminate the backcloth evenly with two photoflood lamps. Make sure you take your exposure reading from the illuminated backcloth only and print the resulting negatives on hard paper (*see* Darkroom).

Projected shadows
The traditional way of projecting silhouettes is to construct a tracing paper screen and position a photoflood behind the subject. This will then project a shadow onto the tracing paper screen. Expose as before by obtaining a meter reading from the brightly lit part of the screen and print negatives on hard paper.

22

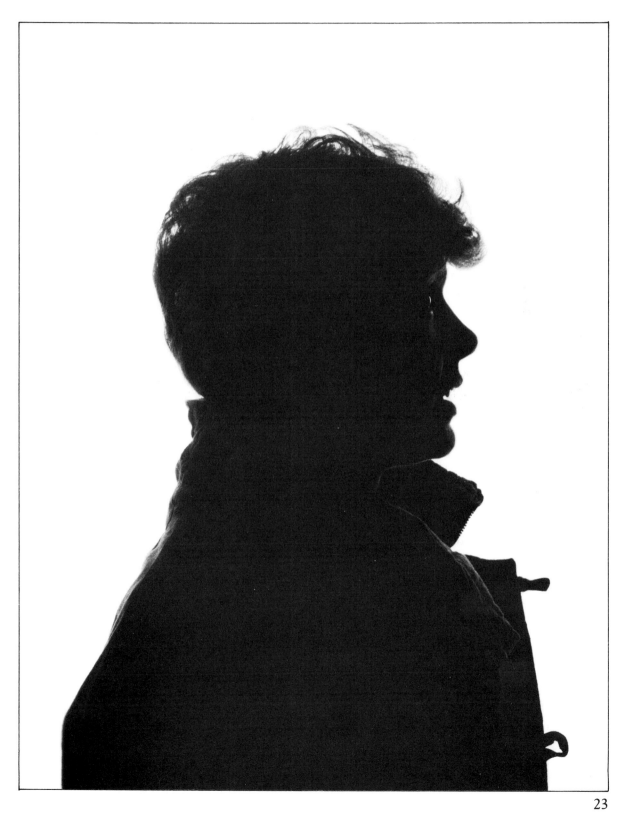

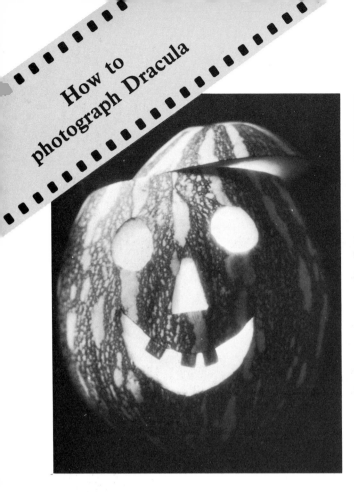

Lighting a pumpkin

Taking photographs with existing light is easier than setting up studio lighting. Existing lights will help you to capture the atmosphere of a picture. To obtain a picture of a pumpkin as above, place a group of small, thick candles inside a carved-out pumpkin and use a fast film, tripod and cable release.

Using daylight

Use natural daylight, as in the picture of the girl (right), to give a profile lighting effect. It is always best to light the front of the face, otherwise facial features will disappear. Use the camera on a tripod, but hold out a sheet of newspaper with the lens poking through, as this will reflect light from the window back to the girl's face sufficiently to pick out important details.

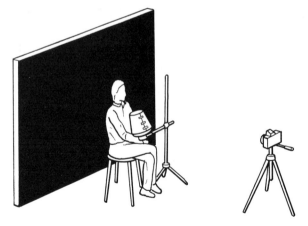

Dracula

By using lighting creatively, it is possible to get dramatic effects. We have all shone a torch up onto our faces to scare our friends; This time, use a spotlight under the chin, add some fangs, and a black background and you are in business! For extra horror effects, use a colour film, make your friend up with white face powder, add blue eye make-up and have some theatrical blood dripping from his teeth.

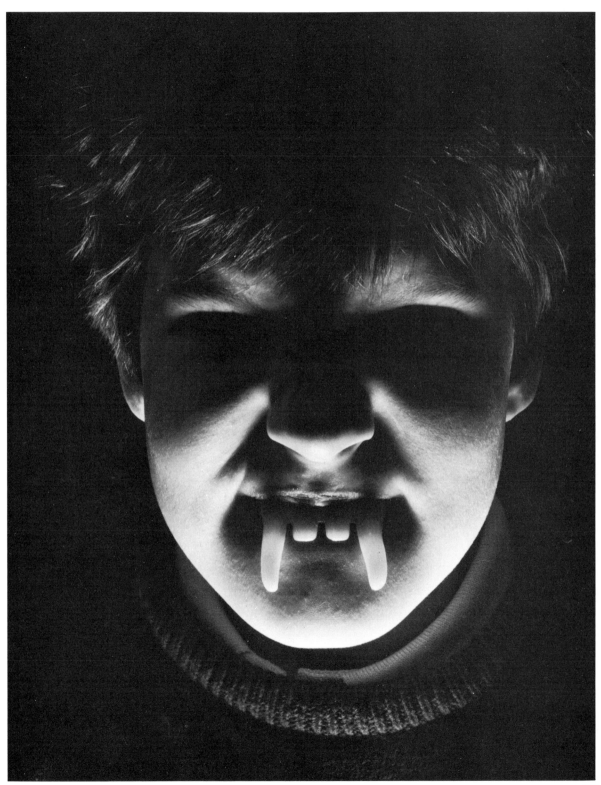

How to photograph a botanical specimen

If you collect botanical specimens, press flowers or are merely interested in the wonders of nature, you need to construct a simple light-box. You will need a wooden box (try the junk shops). Drill some holes on either side for ventilation, add a small fluorescent striplight (available from kitchen & DIY shops), then place a piece of glass on top, with a sheet of white paper underneath it. You may find it possible to reverse the head of your tripod (see above). If not, and you decide to pursue this type of photography, make sure to buy a tripod with a reversible head.

Exposure needs to be bracketed initially. If on manual, this involves altering the f stop to a higher reading, and if on automatic, to a lower reading.

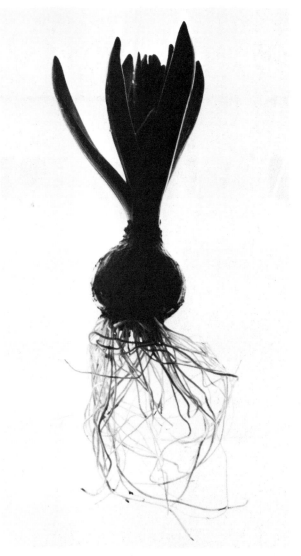

Photographing light patterns

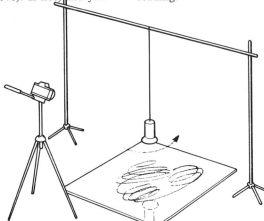

Obtain a torch with a ring in one end and a flat glass over the bulb. Punch a small hole in a small piece of foil and tape the foil to the glass face of the torch. Hang the torch from a suspended rod and start it swinging. Note the types of patterns you see. Now, either place a mirror on the floor (see above) or position a camera under the torch. Turn off all the lights and switch on the torch. Open the camera shutter for about 20 seconds (at f11) and you will get a light pattern, made by the minute beam of light from the torch.

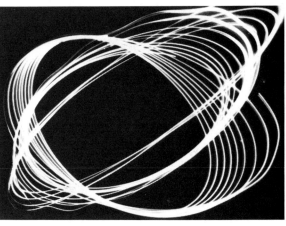

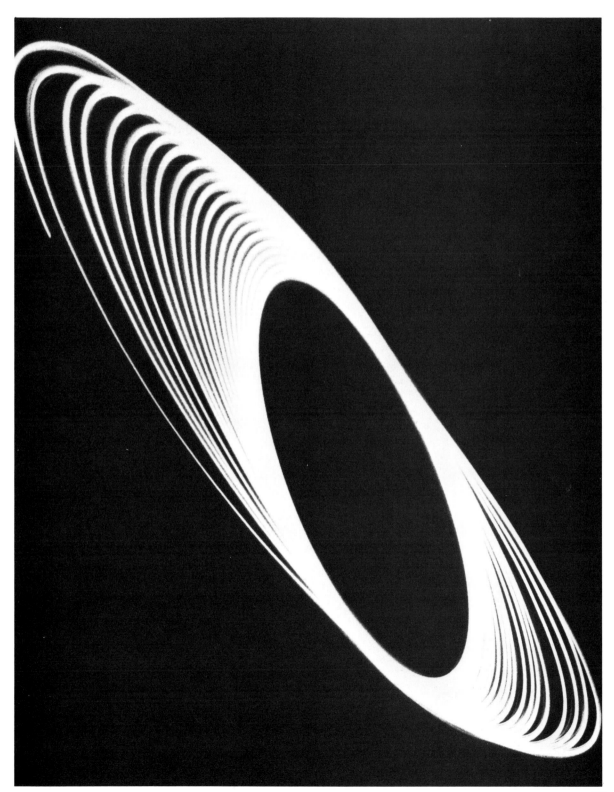

Using light outdoors

When you take your camera outside you will be confused by the number of photographic decisions you will have to make. Indoors it was only a case of focusing, sorting out the artificial light and exposure before taking a picture. Outdoors, things aren't so simple, as most scenes you will want to photograph are much more three dimensional—when you focus on one object, you may find other parts of the picture remain blurred. All is easily explained. As we know from earlier in the book, three of the major controls on a camera are:

1. The shutter speed setting. 2. The f-stop which indicates the size of the diaphragm opening. 3. The distance scale, which helps with focusing. Exposure is the correct amount of light needed to take a photograph. To keep exposure constant, any change in the aperture size must be matched by a change of speed, and vice versa. Speed settings are marked in a steady mathematical progression. You may not have all these speeds on your camera but a typical sequence would be: 1/2, 1/4, 1/8, 1/15, 1/30, 1/60, 1/125, 1/250, 1/500, each setting twice as fast as the previous one.

Aperture settings also follow a strict sequence: f1, f2, f2.8, f5.6, f8, f11, f16, f22, f32, f45, f64. For each increase in f number the opening size is halved and so too is the amount of light passing through.

If light conditions require an exposure set at 1/125 second at f16 but you need to "freeze" a subject, say a bird in flight or a footballer running, you will need a speed of twice that – 1/250 second. To keep exposure constant you must double the aperture opening to f11. Remember, the larger the aperture opening, the smaller the f number.

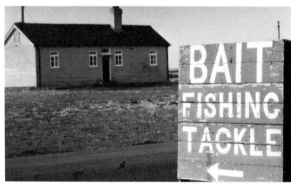

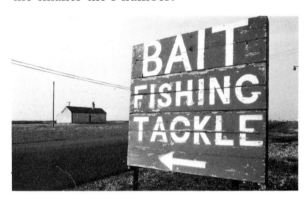

135mm

50mm

35mm

24mm

How much a lens will see
The chart, left, will give you some indication of what you can expect a lens to see (angle of view) and the nearest you can focus it (minimum focusing distance).

Changing a lens
By changing the lens on the camera you can include a greater or lesser amount of picture without changing your own position.

The above picture was photographed with a standard 50mm lens, but by changing to an 80mm lens, which has a narrower angle of view, a more magnified picture is possible.

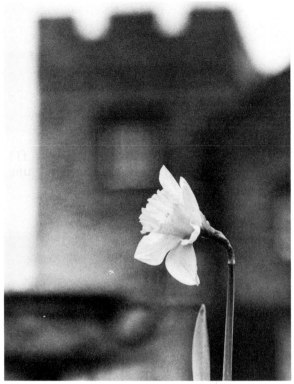

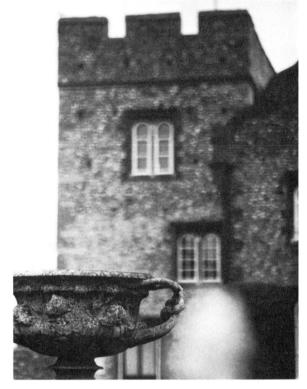

Depth of field

Out-of-focus pictures are usually caused by camera shake and not by incorrect setting of the focus ring. 110 and 126 cameras are notorious for this and need very careful handling. The slightest movement caused by pressing the shutter button is sufficient to cause a blurred picture.

The picture above of a daffodil is a good example of selective focusing. The camera is stopped down to f2 on a normal 50mm lens; depth of field is non-existent. In the second picture, the camera is focused on the garden vase: depth of field is greater when the camera lens is focused on 15ft (4.5m) plus, than on 5ft (1.5m). The further you place your camera from the subject, the greater the depth of field will be. This is apparent in the third photograph of the tower, where the depth of field is almost from the garden vase to infinity.

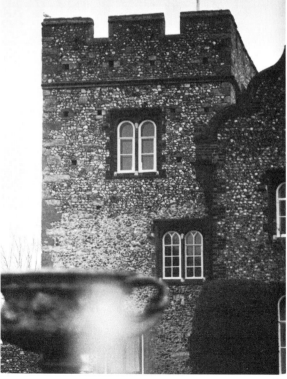

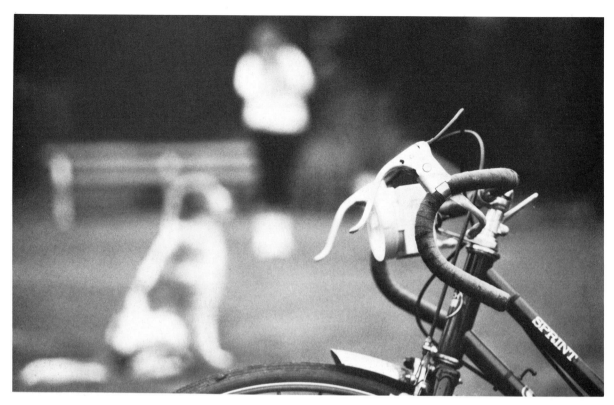

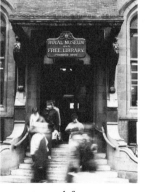

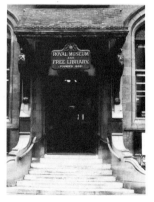

Filling the frame
A bold image can quickly tell your audience the point you want to make in a picture. Also, if the foreground and background are cluttered with unwanted objects, this is a good way of removing them from the photograph.

The technique works extremely well with any self-contained objects. Try it also with family group shots; get in close so the whole family is in the frame, but not half a dozen onlookers as well!

How to remove people
In the two pictures above the same number of people were passing in and out. The difference is that the picture on the right was exposed for 5 seconds rather than 1/20 second, the length of time that the picture on the left

was exposed for.

Because it was a time exposure, nobody had remained long enough on the steps to be recorded. A useful tip if you want to photograph monuments without tourists!

Selective focusing
It is possible to create completely different photographs from the same viewpoint by using a large aperture (f2.8) and

changing focus. The shallow depth of field that you get with a large aperture (f2.8) enables you to focus on individual elements in a picture leaving the rest blurred. This technique is often used by wildlife photographers who might focus through trees to a deer in a thicket. The trees would be a blur whilst the deer would be pin-sharp.

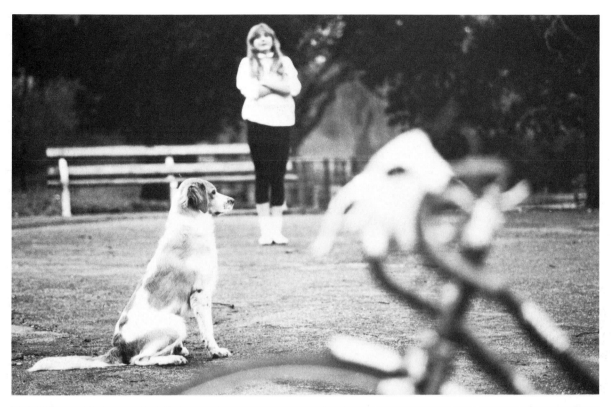

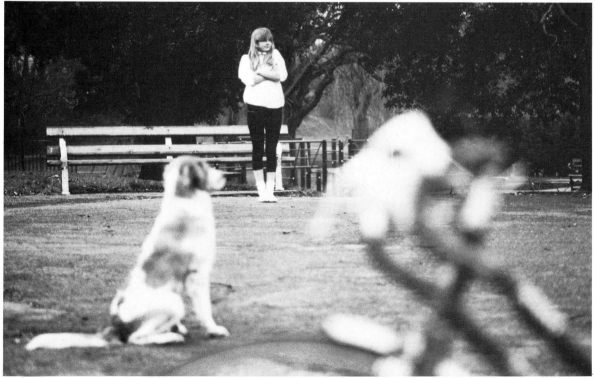

Using light outdoors/3

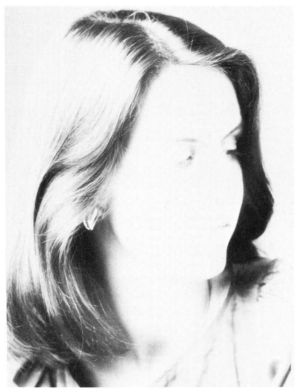

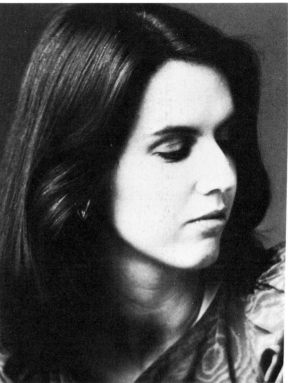

Over exposure

Automatic exposure makes for accurate exposure all the time! Not strictly true; it may be right for three-quarters of all pictures you take, but sometimes you need to overule your automatic exposure. This is especially true for colour slides. Colour negative film can be automatically corrected during printing, slides cannot.

There are ways to short-circuit your automatic system. Some cameras have a compensation dial with which you can bracket. Some cameras have a memory lock which enables you to take a close-up meter reading before stepping back to take the picture. Another device is the film speed dial; resetting this will alter exposure. To increase exposure by 1 stop (to make the picture lighter), set the film speed dial at half the actual speed of the film. To decrease exposure by 1 stop (to make the picture darker), set the film speed dial at twice the speed of the film.

Always remember to return the dial to its correct setting. To help you to remember this, tear off the film pack top and insert it in the window at the back of the camera case. In the three pictures on this page we have examples of underexposure, correct exposure and overexposure. In underexposure, shadow details are lost because too little light is reaching the film; in correct exposure enough light is reaching the film to show detail in both shadow and high lights; in over-exposure too much light is reaching the film, light areas are lost and shadow is showing too much detail.

Exposure chart

	Normal Subject	Cloudy Bright
Kodacolor VR 100	1/125	1/125
Film speed ISO 100	f/16	f/5.6
Kodacolor VR 200	1/250	1/125
Film speed ISO 200	f/16	f/8
Kodacolor VR 400	1/250	1/250
Film speed ISO 400	f/22	f/8
B/W Print film. Tri-X	1/500	1/250
Pan 400	f/22	f/11

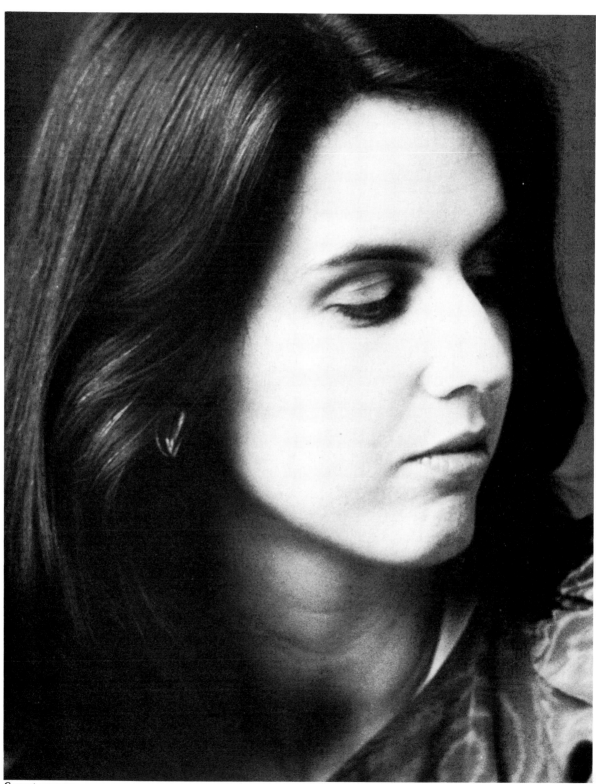

Correct exposure.

Using light outdoors/4

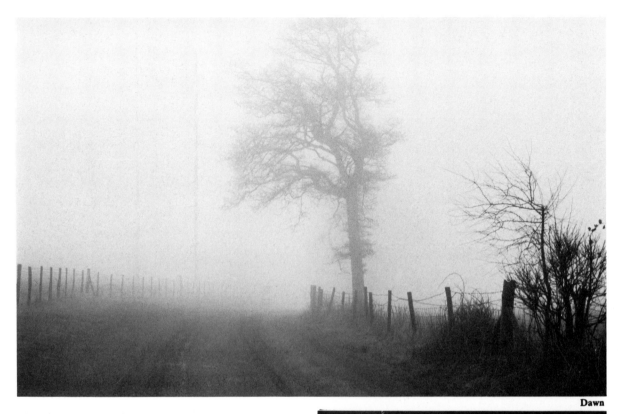

Dawn

7am Dawn. This is the time many of the best photographs are taken. In summer the light is clean and clear, in spring and autumn ground frost and mist linger at this time. This is the best time to take outdoor photographs.

10am The mist has gone, the fisherman (right) has finished his work. The rays of the sun provide a hard, clear light, ideal for reflecting off the fishermans apron in the shadows of his hut. Make sure the light works for you; plan your photographs so that you can be in the right place at the right time. Plan shots in advance.

12 noon Not the best time to take photographs, as light and shade are hard. Very difficult to expose correctly. There is usually a heat haze by now for landscape photographs.

6pm Dusk. The ideal time to take cityscapes. By careful control of exposure you can emphasize qualities of the city like in the neon picture (right), underexposed so as to fill in shadow and to add emphasis to the neon signs.

7pm Sunset. You must be positioned well for sunset pictures; pre-planning is essential and light levels are falling all the time, so bracket your film. If not satisfied, you can always return another day!

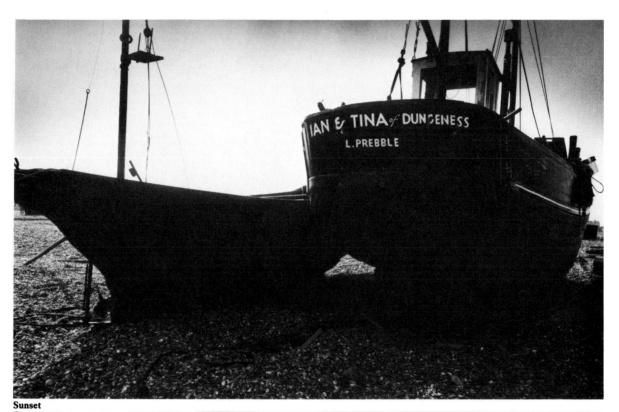

Sunset

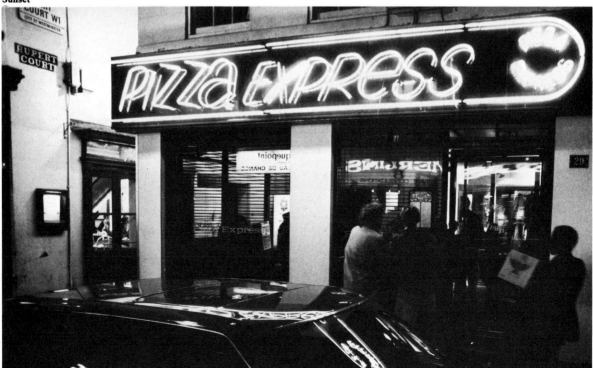

Using light outdoors/5

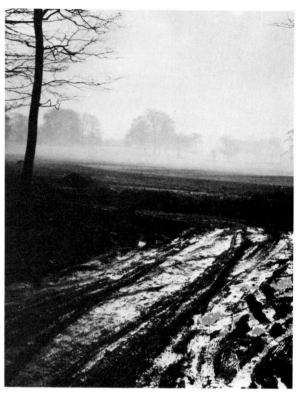

Unusual weather adds drama to a picture. Brooding skies, angry clouds infuse a picture with a quality which is always exciting. Sky conditions are always changing, so be prepared. An otherwise dull picture can be enhanced by emphasizing the sky. Use it to portray moods; the silent lake reminiscent of King Arthur, mist swirling over its inky depths, a log imitating the Lady of the Lake's outstretched hand; the tropical sunset, all the colours of the rainbow, setting into stark relief the swaying palms. Filters can add dramatic contrast, the most useful being yellow and red which darken the blue and emphasize the white of the cloud.

If most of the picture is to be sky, a wide-angle lens to give an even greater degree of spaciousness.

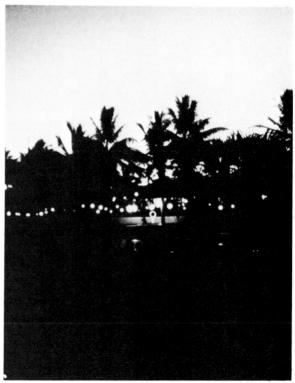

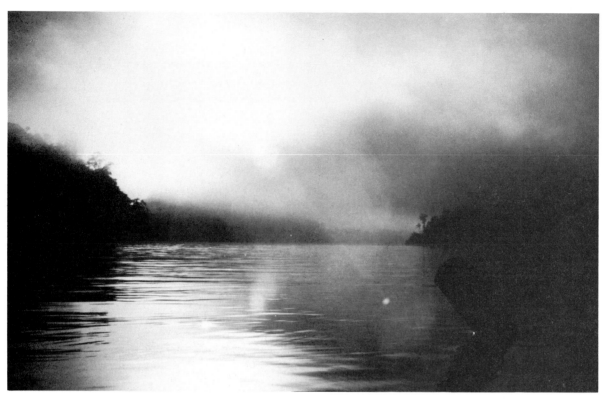

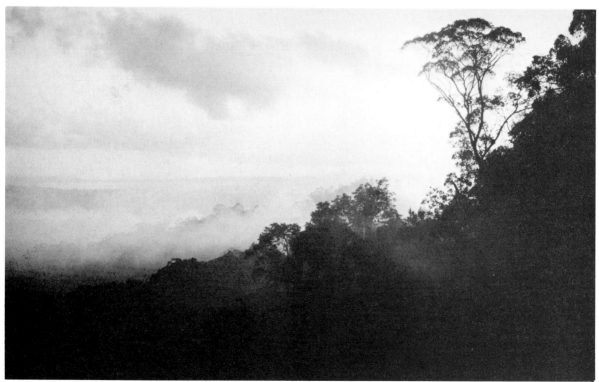

Freezing the action

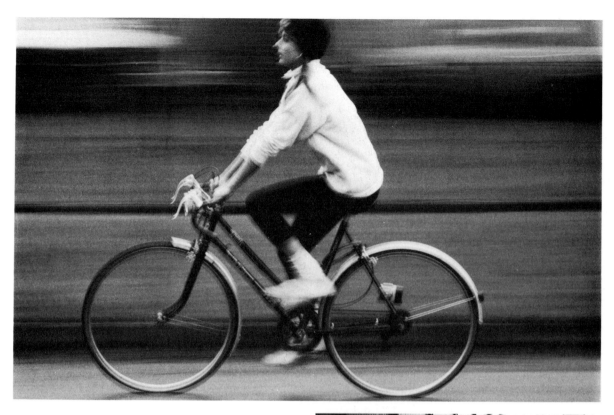

Panning
Panning means taking a picture at a slow shutter speed whilst you swing the camera at the same speed at which the subject passes. In the picture of the girl on the bicycle, a slow shutter speed of 1/20 second was used. Try to gauge the speed of the subject and set the shutter speed equal to it, e.g. 30mph would mean a shutter speed of 1/30 second.

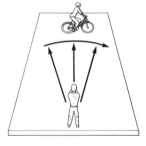

Indoor events
Use high-speed film and a high shutter speed to freeze the action as in the ice rink. Sometimes it is nice to show blurred movement so as to create an atmosphere. Always think creatively before taking a picture.

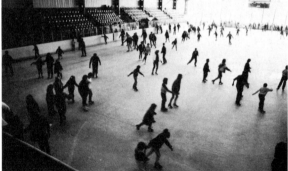

To stop motion, use the fastest shutter speed possible, and on all but the brightest days, use high-speed film. This will enable you to use a fast shutter speed and still be able to use a good depth of field aperture setting.

The dog (right) was caught mid-jump whilst looking at her mistress.

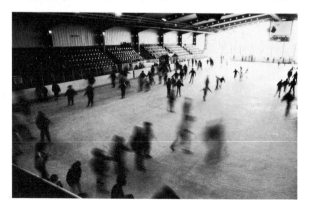

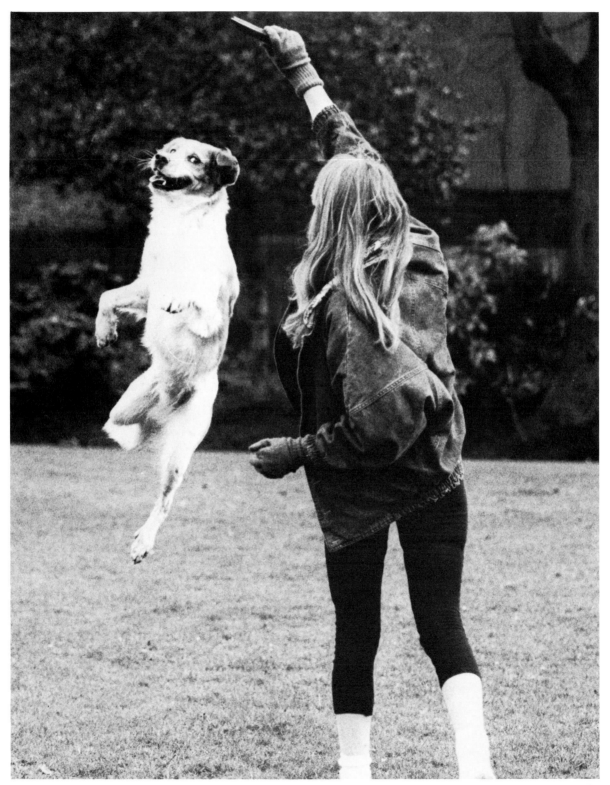

Composition

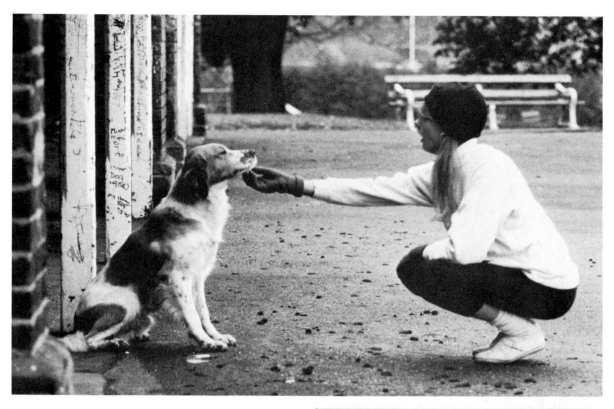

Lines are present in all pictures, but they dominate in a few. Use lines to direct the eye towards points of interest. In the picture (far right) the lines of the cut log lead to the men burning the waste branches.

Use shape to frame a picture and add interest. The picture of a cathedral (right) is perfectly framed through the use of a stone arch. Line and shape come together in the picture of a girl and her dog (above). The subject itself is two dimensional and graphic, a simple story simply told. The diagonal receding lines of the posts add perspective to what could have been a rather flat subject.

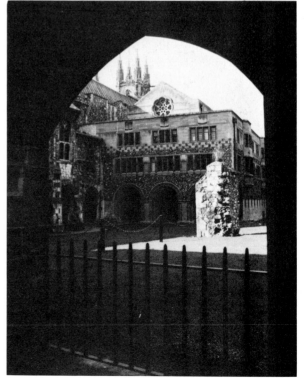

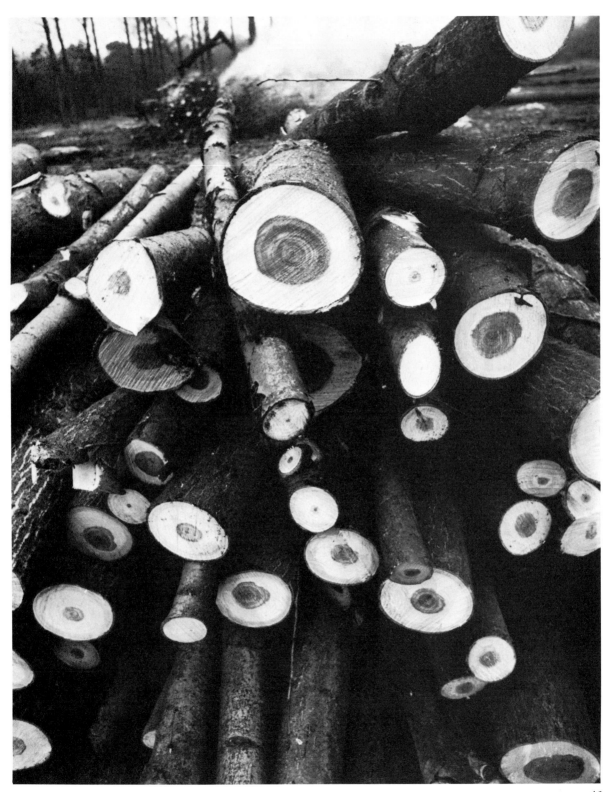

Pattern

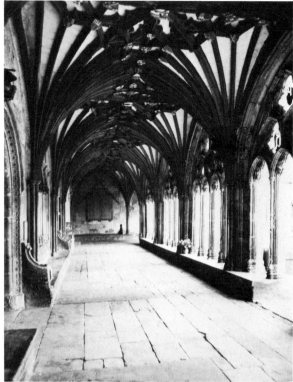

Pattern is an important part of photography. Use your eyes, look around you; even the shells on the beach will make a pleasing photograph. The seaside provides a huge amount of pattern and texture. Take a walk along a beach with a camera and see what you can find; the delicate tracery of ironwork on the pier, the see-through shapes of people sitting in deckchairs, the amazing pattern and colour of a seaside sweet shop, the pattern of oil on water, footprints in the sand – all just waiting for a creative mind. Take care with exposure and allow for reflected light from the sea and sand.

Capturing a building's mood
When photographing a building, walk around looking for a more unusual position or dramatic effect. Try to interpret a building's mood; use the weather if possible. Consider framing the building with a foreground device such as the branch of a tree – these will give added depth. In the cloister picture above the tracery and diagonal lines add framing to the picture, giving an illusion of great depth.

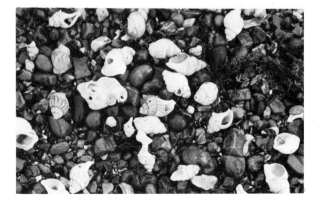

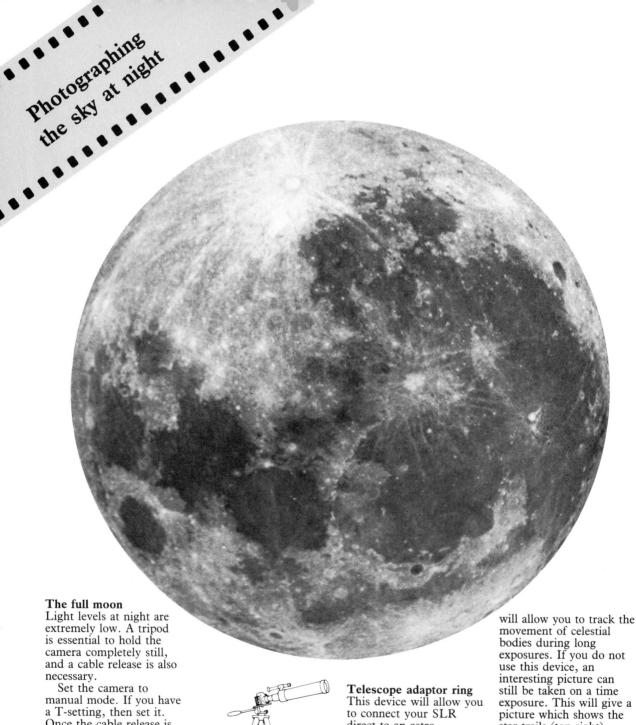

The full moon

Light levels at night are extremely low. A tripod is essential to hold the camera completely still, and a cable release is also necessary.

Set the camera to manual mode. If you have a T-setting, then set it. Once the cable release is triggered it will remain open until the shutter release is pressed again.

To photograph the moon above, a 400mm lens was used with a 1/125 second exposure. Bracket exposure. Film used: 50 ASA. A yellow filter was used to enhance the dark regions of the moon.

Telescope adaptor ring

This device will allow you to connect your SLR direct to an astro telescope. If you want to experiment before buying one, join your local astronomical society.

For any exposure more than 30 seconds, an equatorial drive is necessary. This is a mounting which rotates smoothly in a circle, taking 23 hours 56 minutes. This will allow you to track the movement of celestial bodies during long exposures. If you do not use this device, an interesting picture can still be taken on a time exposure. This will give a picture which shows the star trails (top right).

The best time to photograph the stars is on a cold, clear night. Make sure your lens does not fog. For moon pictures, make sure the moon is high in the sky so as to avoid atmosphere haze, and photograph away from city lights and as high as possible.

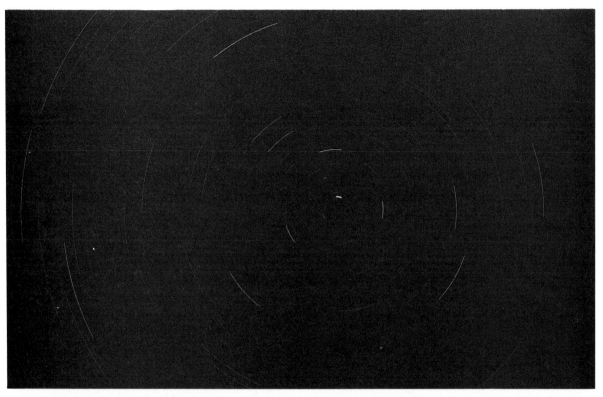

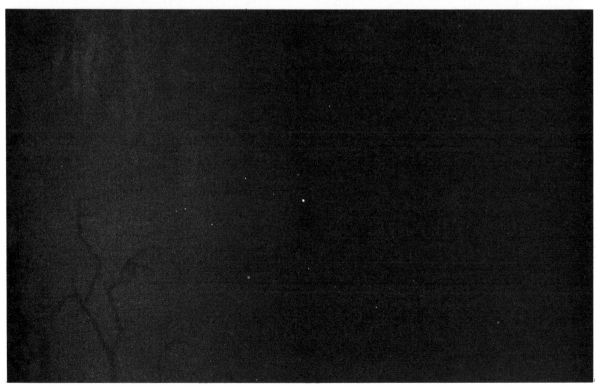

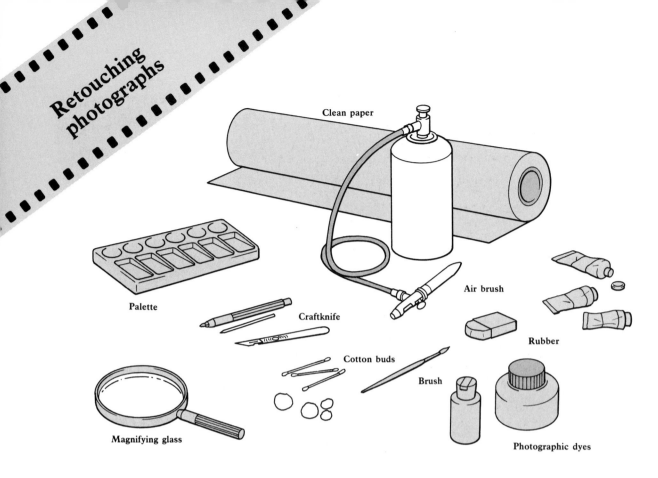

Clean paper

Air brush

Palette

Craftknife

Rubber

Cotton buds

Brush

Magnifying glass

Photographic dyes

A small amount of work can transform a messy spotty print into something worthwhile. All of your retouching will be done on B/W prints, negative and transparency retouching is for the professionals. For print retouching you need the following basic equipment, a good quality brush, preferably around 'oo' size, buy this from your nearest artists supply shop. You will need retouching dyes, these you can buy from your photographic supply shop. A small craft knife with rounded blades, some absorbent paper, a small jar or mixing palette to hold water and dyes, a magnifying glass for working on tiny details, as you get more proficient you will be able to experiment with an airbrush gun. Look after your equipment but especially your brushes, make sure you keep a good point on it and always return it to its plastic sheath for safekeeping. It doesn't matter how careful you are, there will always be white spots caused by dust on your prints.

The best type of retouching dye is photographic dyes, watercolour and water-soluble dyes tend to leave surface marks.

There is no quick way to retouch a print it needs practise and patience.

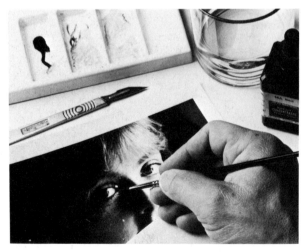

Make sure when retouching that you work in a clean, well-lit, quiet area, you need time, patience and no interruptions to be successful. Start with the lighter tones, and build up density very slowly and gradually till it matches the surrounding area. Test the dye colour on a spare piece of photographic paper first. For black spots use the craft knife to remove gently.

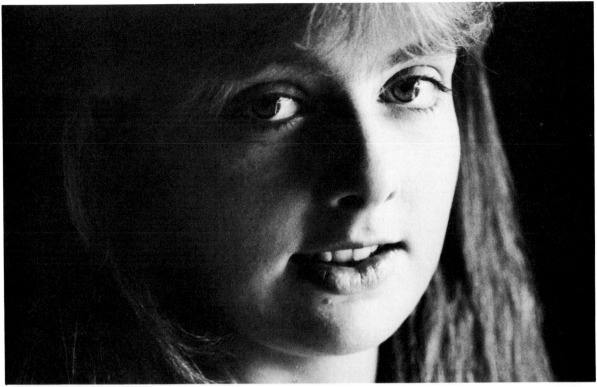

Retouched photographs

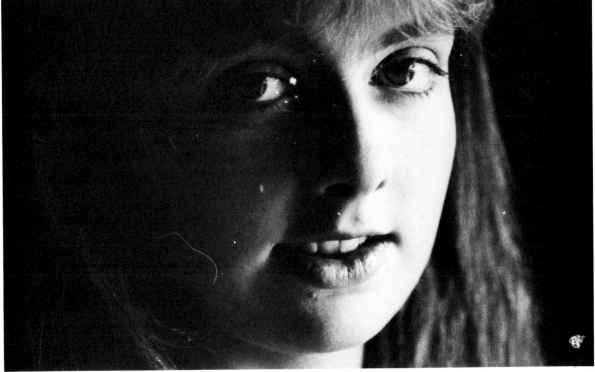

Unretouched photograph

47

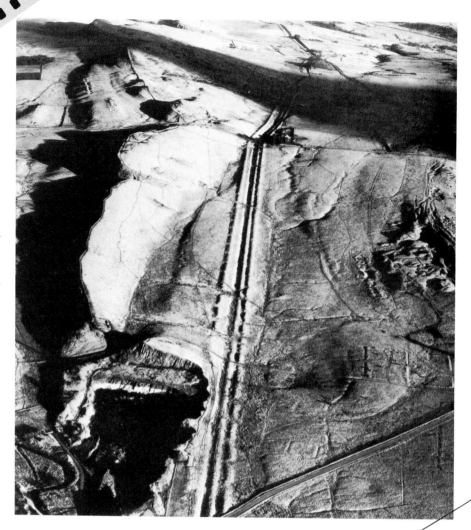

Photographing from an aircraft

Try to organize a trip with a flying school; most offer test lessons. Make sure you can shoot from an open window or door (ask permission and be sure you are securely strapped in). The best times to take pictures are early morning or late evening. Textures and details will be more obvious, also details which are not apparent from ground level will show up more if a suitable time of year is chosen. Archaeological sites will be apparent if enhanced by drought or a light frost.

Keep to the shortest possible shutter speed and use an ultraviolet filter to reduce haze.

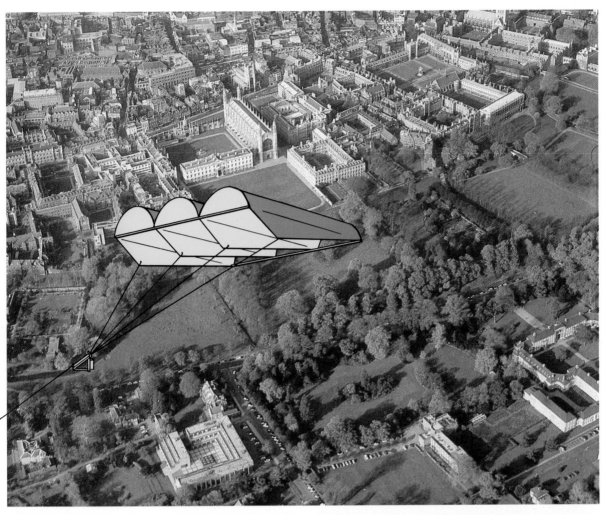

Taking pictures with a kite

To take aerial pictures of a particular site (see opposite, Hadrians wall) which will enhance details not apparent from the ground, an effective idea is to use a kite or a small model aeroplane. Make sure you use a kite with good lifting capability; build a frame which will hold the camera securely and in the correct position. Release the kite and the camera will have a smooth lift-off. To recover the camera, wind the kite in slowly and catch the camera while the kite is still flying. Set the shutter speed with a timing device on the shutter release cable – two minutes should allow the kite to reach about 1000ft (300m). Quite laborious to do, but stunning pictures will result.

Photographing at dusk

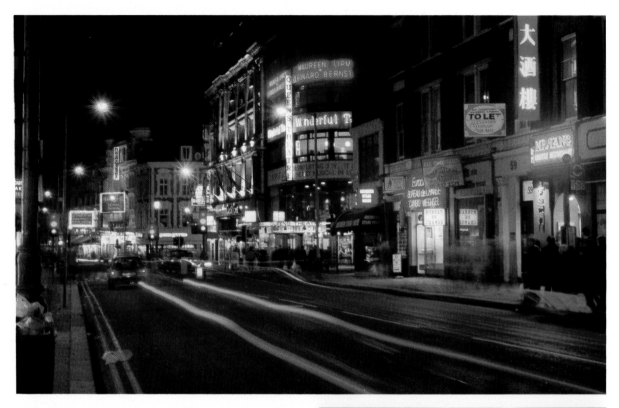

Taking pictures at night is exciting but full of problems. It is best to take the night pictures at dusk, just before darkness sets in. If you photograph in total darkness, the picture will just have harsh highlights and no shadow detail.

Colour pictures pose special problems, especially if there is a mixture of natural and artificial light. Daylight film makes artificial light appear warmer; using artificial light film causes daylight to appear blue. With the fast films now available you can photograph anything, although a tripod and cable release are essential.

City lights, photographed at 1 second, + 8 on EHB Ektachrome: neon photographs, 1/25 second at f8 on Kodachrome.

Neon
The multi-coloured lights of neon make fantastic patterns of colour, the most common fault is under exposure, you should experiment with a range of exposure times, using a tripod or secure resting place for your camera. Exposures of around a minute at f16 using 64ASA film will be about right.

Problem exposures

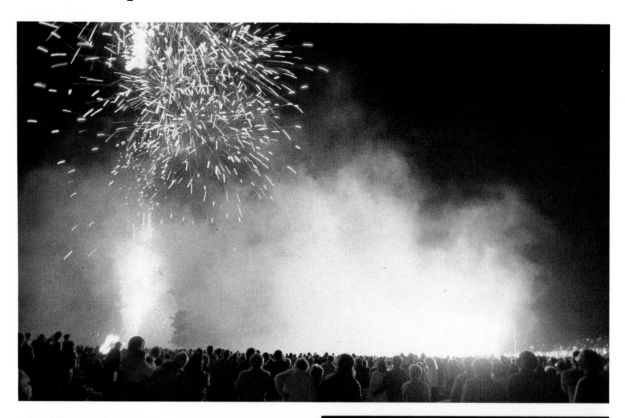

Fireworks and displays
Use a tripod and hold the shutter open long enough to take several fireworks going off. For a long exposure and to record several fireworks, mask the lens with a piece of black card between exposures to fireworks. Bracket exposure, but around f16 for 20 seconds would be about right. **(above and opposite).**

Stained glass
Avoid taking pictures of stained glass in direct sunlight; the best time is on a day which is slightly overcast, when the light falling through the glass will be even and give a good rendering of the colours. To photograph details, ask permission to use a ladder, attach the camera to the top of the ladder. Make sure the

camera is parallel to the glass surface and use black paper to frame the detail you want (this stops light flaring from other areas).

Bracket exposure, but a typical picture would need 1 second at f11 on Ektachrome 64 (daylight).

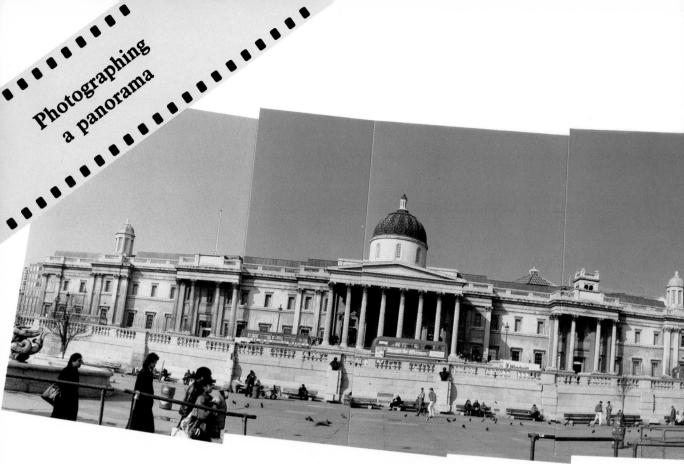

Colour mosaic panorama
There are times when it would be nice to get the whole scene in, a city square, a waterfront . . . No lens can handle this wide area, but the difficulty can be overcome by taking a series of overlapping pictures on a tripod.

Set yourself up in the centre of the scene. Take your first photograph on the left, remember the detail on the far right in your viewfinder and then move the camera round to take the next picture, overlapping slightly with the last picture taken. When you get the prints back, mount them in a continuous strip and have a copy made.

If you wish to remove the people and traffic, use a slow film and a time exposure.

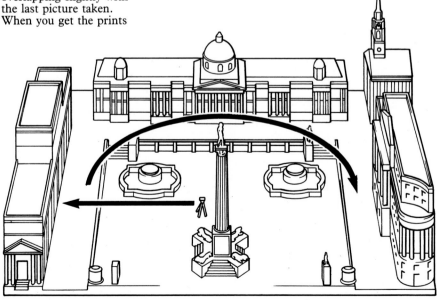

54

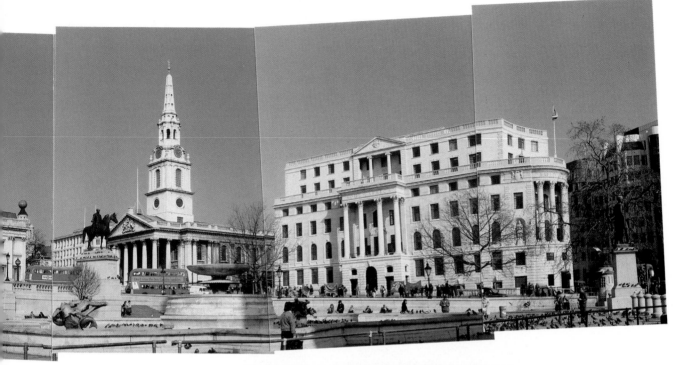

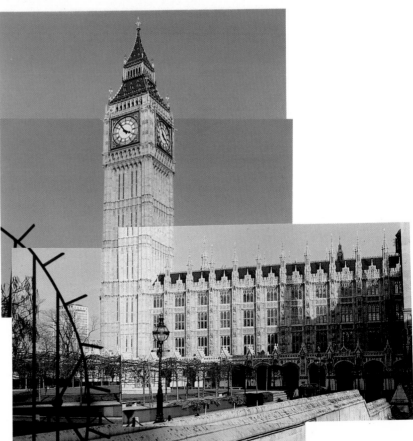

Photographing under water

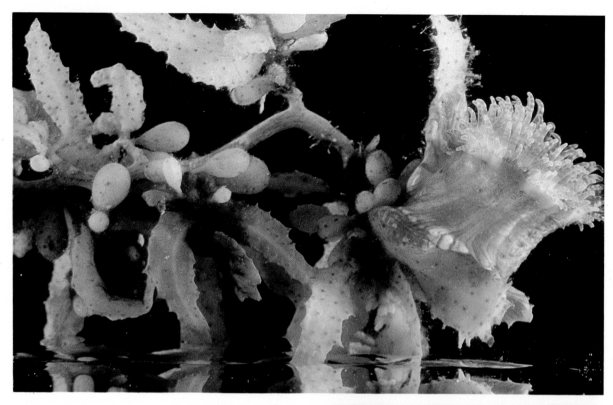

Tropical fish and small seashore animals can be photographed realistically by using a glass tank. Make sure the glass is clean and the water clear; use a polarizing lens to cut down on reflection and mask the camera with a sheet of black card to cut down on reflection from the camera. Use a black background to the tank, then position your electronic flash above the tank, which will imitate daylight and bracket your pictures.

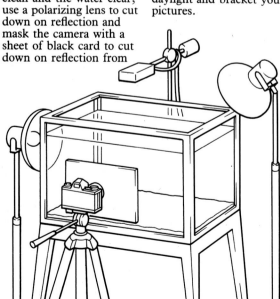

Underwater photography
Shallow water is best for taking pictures. The picture above was taken with the Canon AS6 all-weather camera, whilst snorkelling on a reef. The picture opposite was taken at 60ft (20m). The predominant colour is blue; at this depth the water has absorbed all the red and yellow. Flash will return the lost colours.

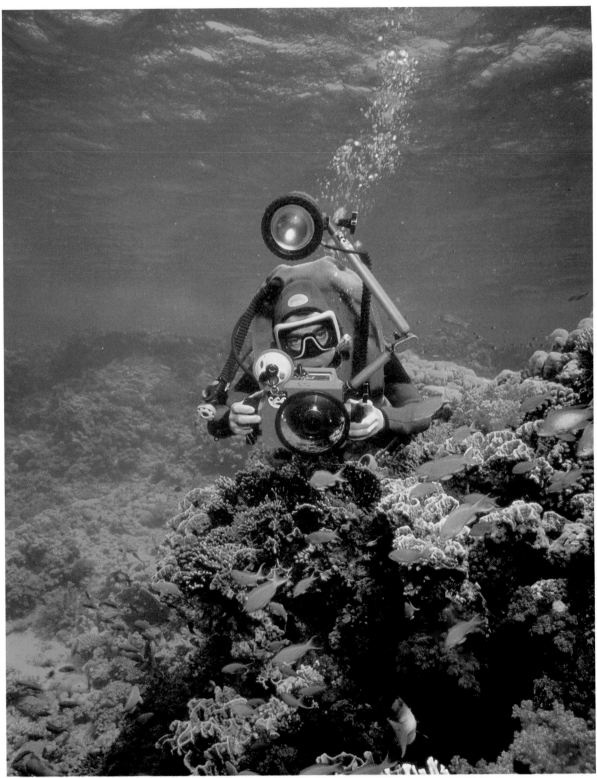

Photographing animals

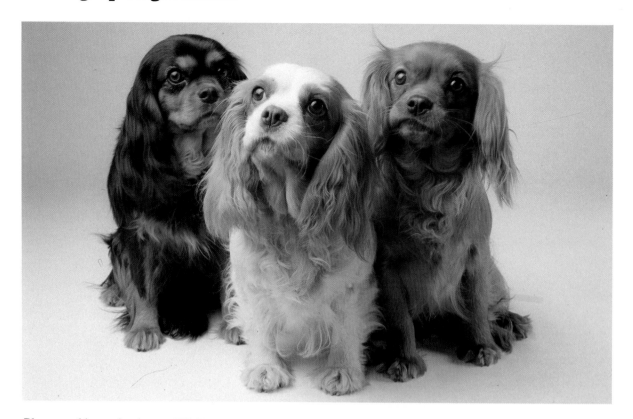

Photographing animals

Pets are the easiest animals to photograph, as you know their habits and how to keep them amused. Try to attract the animal's attention as you take the picture by snapping your fingers or calling it by name. The three dogs (above) were kept attentive by holding a biscuit above the camera; the background is a curved sheet of paper. Pictures of very small pets, like mice or lizards, need a close-up lens so you can fill the frame. At the zoo, to avoid wire mesh across the picture, choose a large aperture on the lens and hold the camera as close to the mesh as you can. The mesh will be out of focus and will not show up on the finished picture.

Wildlife photography

Trying to photograph wild animals can be extremely frustrating. The ideal solution is to construct a hide. A simple wooden frame, covered with green or brown canvas is ideal. Build your hide as quickly as possible and leave it for a day so that the wildlife can get used to it. There will be long hours of waiting, so make the hide as comfortable as possible with a folding seat, hot drinks and plenty of warm clothes. If photographing a nest, a good trick is to enter the hide with a friend. When the friend leaves the birds assume the hide is empty and will carry on with their business.

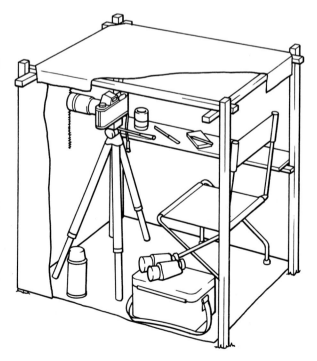

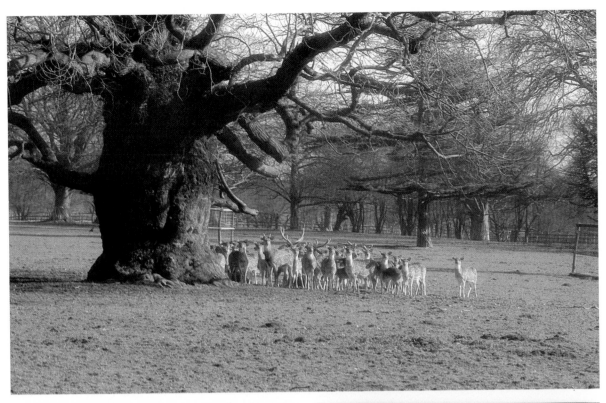

Close-up photography

Close-up photography is exciting. With the use of your camera you can start to explore a world which most people do not realize exists. One of the major problems is light; tungsten light is ideal to use indoors – use two photo-flood lamps with tracing paper diffusers draped over them.

Make sure the camera is rock-steady on the tripod. You will need a long exposure, but bracket and keep notes. Practice is essential with this form of photography.

Close-up equipment
The easiest way to start taking close-up pictures is to buy close-up lenses. Exposure will still be metered through the lens. Close-up lenses can be used indoors and outdoors.

On some cameras, you can remove and reverse your normal lens to take close-up pictures. Handle the lens carefully to avoid scratching, hold light against the camera mount and use your fingers to stop light leak.

Special macro lenses are available which will bring the subject much closer. Extension tubes and bellows can be used in conjunction with macro lenses to give first-class results.

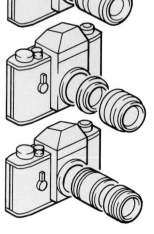

60

Holiday memories

Before going on holiday
A couple of weeks before going on holiday, expose a test roll of pictures. Buy spare batteries for the camera and flash unit.

Check that your camera is covered by insurance – ask your parents.

Buy and pack film in a clear plastic bag; carry the films and camera as hand luggage – do not pass them through any X-ray security machines. Tell the security people that X-rays will damage your film.

Take your camera and accessories purchase receipts with you, as you may have to prove to Customs that you did not buy the equipment overseas. Travel light, take only what you think you will need, but always take plenty of film.

Research your holiday, find out before you leave home what you can expect to see and plan accordingly. But do not be a pain, remember on a family holiday that you are not the only one!

A good list of equipment to take would be 35mm camera, flash unit, normal lens, telephoto or telephoto zoom lens, tripod, filters, cable release, cleaning kit, soft canvas bag, film.

Look upon your holiday as a picture diary. Photograph all stages of your journey and holiday; do not try all the time for fantastic shots, remember that even a snapshot will be a treasured memory.

Sepia prints To add nostalgia to holiday photographs it is possible to sepia-tone B/W photographs. You bleach the original image and redevelop with a sepia tone. Follow the manufacturer's instructions.

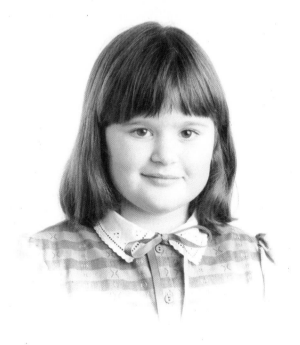

Keeping photographs

Work out a filing system before you collect too many photographs. There is nothing worse than enthusiastically taking pictures, only to realize a year later that you have a huge pile of prints and transparencies, many of which are mixed up and you are not sure where you took the rest of them. So be methodical.

Start with a system of numbering bags. Buy a card index file, fill in an entry for every roll of film taken, and transfer any notes from your note book to the card index.

This way you will be storing knowledge and information. When you look at a transparency and need to repeat that picture, all the details should be on your card index.

Make a contact sheet of every black and white film, and write the film number on the back.

File the negatives separately from the contact sheets. Work from the contact sheets, only taking out the negatives from which you need to make prints. One of the best designs of negative bag is a clear acetate sheet which is divided into strips which hold the negatives. It is possible to contact print straight from this bag.

For filing transparencies, there are plastic sheets which have individual pockets for holding slides. They come in two handy sizes.

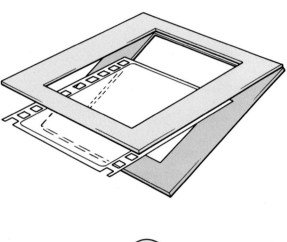

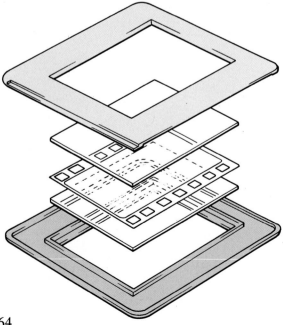

Mounting transparencies
There are two types of transparency mounts. The simplest type is a single piece of self-adhesive white card with a cut-out window. Position the transparency correctly, fold the card and press down. It is best to slide over an acetate sleeve to protect the transparency from fingermarks and scratches.

The second type of mount is more expensive but much more satisfactory. The plastic, glass-faced mount can be used perfectly safely in a projector, whereas the card mount is not strong enough to be used in a projector. The glass surface should be cleaned first. Make sure the transparency is free from dust and fingermarks, then "sandwich" the transparency and clip together, mark the viewing side of the transparency with a red dot – this will help when you come to load the projector.

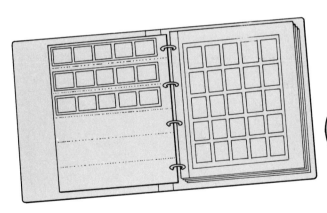

Filing negatives
Store negatives so that they can easily be found when they are needed. 35mm negatives should be cut into strips and filed in a negative file which has clear plastic pages (*see* above). Make sure every sheet is numbered with a file number, also marked on the back of the contact sheet made from the negatives.

It is possible to adapt ring binders bought from your local shop.

Carousel storage
Kodak Carousel projectors use circular magazines to hold slides. This is a useful way of storing slides in a dust free atmosphere.

The Carousel tray holds 80 or 140 slides. To take out all the slides, turn the tray upside down with the lid on. The slides will drop into the lid. Open the tray slightly and run a finger round inside – this will stack the slides into a block, much easier than trying to take out slides individually.

Keeping photographs/2

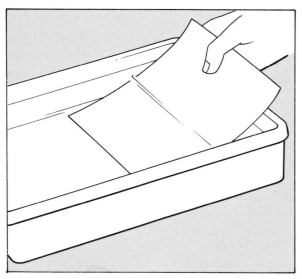

1. Wet-mounting prints involves sticking the prints on a mounting board with glue. Before applying the glue, soak the print you want to mount with a reject print of the same size.

2. Remove excess water from both prints with a squeezee. Use a piece of clean plastic or formica as the base.

3. Brush the glue onto the mounting board. Stick on the reject print and turn the mounting board over. Brush glue on and stick down your good print. This will prevent warping of the mounting board.

4. Align print correctly and press down onto board, carefully trim all four sides with a sharp craft knife and metal ruler. The prints will dry with a nice smooth surface.

Displaying prints
Arrange the pages
creatively, rerun
contrasting small pictures
with large ones.

Mounting with adhesive
Do not use ordinary
domestic glue, as this
type of glue contains
solvents which will attack
the photographic image.
Glues to be avoided are
fish-glue and acetone
solvent glues. Cow-gum
or rubber-gum are the
best types to use. For
giant enlargements and
wet-mounting, use
wallpaper glue, mixing as
for vinyl wallpaper.
Double-sided tape can be
used, as well as album
corners.
 To use rubber-gum,
spread a thin layer across
the entire back of the
print. Repeat this on the
mount and, leave both to
dry. When dry, carefully
align the print to its
correct position, and
smooth down. Avoid
trapping air bubbles.

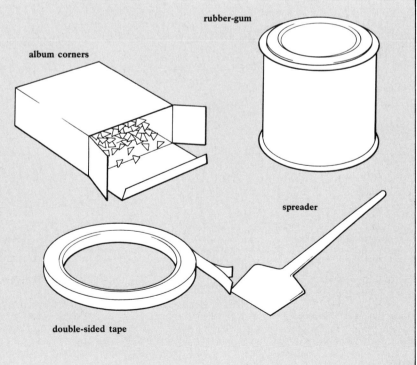

album corners

rubber-gum

spreader

double-sided tape

Making picture frames

The sheer variety of picture frames available is staggering. Do not restrict your choice to modern ones. A cheap way to frame is to visit flea markets and junk shops. Old wooden moulding can be converted into picture frames – all you need is a mitre block (*see* below). There are ways of displaying pictures around the house without using frames at all: you can mount directly on to chipboard and tape or paint the edges; giant enlargements can be used to cover an entire wall; posters can be made using exotic papers and your prints; a novel way to use photographs is to cover the slats of a Venetian blind with a photograph cut into strips – the picture appears when the blind is closed.

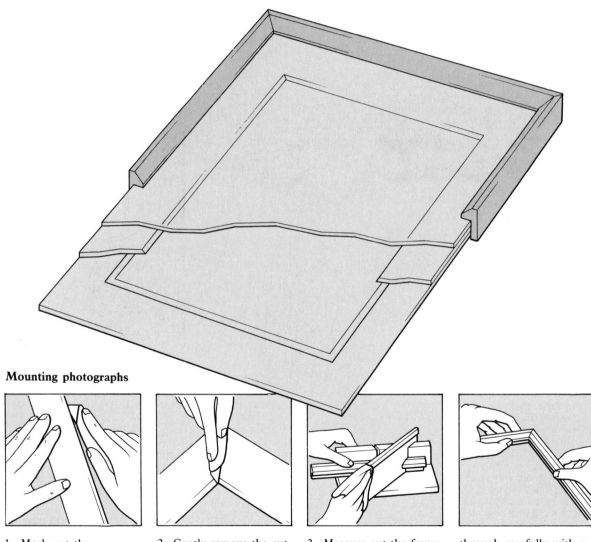

Mounting photographs

1. Mark out the dimensions of the picture on the mounting card, then cut with a sharp craft knife held at an angle of 45° and a steel ruler.

2. Gently remove the cut-out centre of the card, clean up the edges and corners and make sure the bevel you have cut on the card runs true.

3. Measure out the frame very carefully so that it will fit the mounting card and hardboard back on the outside edge. Hold firmly in a mitre box and saw through carefully with a tenon saw.

4. After having sawn all four edges, check that they match correctly at corners, glue and leave for

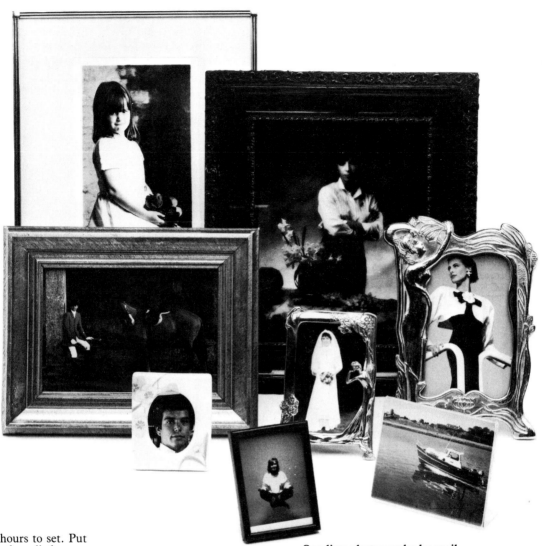

24 hours to set. Put together all the components as in the large illustration. Hold hardboard back into the frame by nailing very small nails along the back edge. Hunt round the junk shops for old picture frames, (see above) none of the frames illustrated cost more than £5 and most a good deal less. Use marbled gift wrapping paper for border decoration, experiment with silver foil and metallic papers, strip old frames down to bare wood, and varnish. Be creative!

Sending photographs by mail

There is nothing worse than receiving a badly damaged photograph through the post, so make sure it is carefully wrapped and protected by a thick sheet of cardboard before you send it.

If it is a large photograph, the best way of sending it is to roll it up and put it inside a cardboard tube. Make sure you tape up both ends securely.

An interesting way of sending photographs through the mail is to make up your own postcards.

If you live in a historic area, it is nice to send postcards to your friends of some famous building or event.

It is possible to buy postcard printing paper with the writing already on the back. Print up a batch at a time and send them out on birthdays and at Christmas.

69

Viewing your photographs

Transparencies are meant to be viewed with light behind them. By transmitted light, a transparency will give a much richer colour than a print because light is going through the film and is not being reflected back by a white paper backing.

The only drawback is that specialized equipment is needed to view transparencies.

A transparency begins to fade when it is projected too often, a point to keep in mind, if you have a favourite slide. Have copies made professionally so as to keep the original in pristine condition.

Do not use a projector without a built-in cooling system – if a slide is allowed to linger, it may melt!

Choose a projector with two points in mind; one, make sure the image projected is sharp, bright and brilliant; two, make sure the projector is designed to minimise heat and noise from the motor.

Standard projector

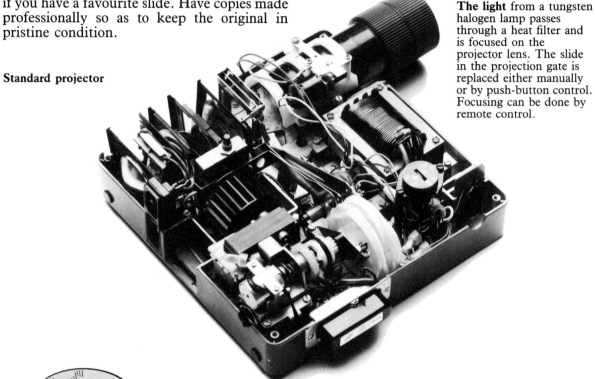

The light from a tungsten halogen lamp passes through a heat filter and is focused on the projector lens. The slide in the projection gate is replaced either manually or by push-button control. Focusing can be done by remote control.

Kodak Carousel
The most popular projector around. It has been in service for many years and is easy to operate. Known to have run continuously for weeks.

Hand-loaded projector
Most often used for 2¼in (6cm) transparencies. If you do buy one of these models, make sure it is robust enough for what you have in mind.

Handviewer
Handheld viewers are ideal for pre-selecting slides for a show. Some have a built-in light source, which may show a slightly different colour than a normal projector lamp.

Think carefully before you make up a magazine or carousel – plan the show, start off with a title projected on a slide – you can use Letraset to add lettering. Try to build atmosphere and detail and work out what you will be saying.

Make sure it is interesting to your audience; entertain them and they will want to come back another time.

Using the projector
Once you have sorted out a projector, the next most important thing is to organize a suitable room and screen.

The room must be dark, as even a small amount of light will affect the richness of the transparencies.

The audience should be at a distance of about five times the width of the screen.

Do not overload a small projector. Keep your audience small – if you find you have to go too far back with a small projector, you will reduce the illumination and quality of the transparencies.

Light boxes
A light box is essential for checking and comparing transparencies. The top surface is of opaque glass, alternatively it could be made of translucent plastic, which will diffuse the light from below. Always use fluorescent tubes of the daylight type to illuminate the box. Switch the light box off when not using it to stop the build up of heat.

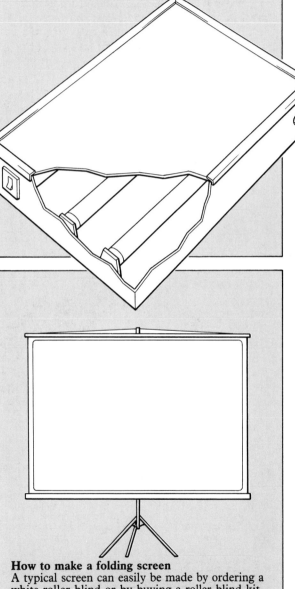

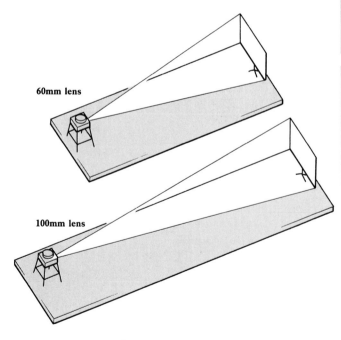

60mm lens

100mm lens

The diagrams above show how different projector lenses allow you to project an image of a standard size 60in (1.52m), with your projector at different distances from the screen.

At the top, the lens is 60mm and is 9½ft (2.9m) from the screen; at the bottom the lens is 100mm and is 15ft (4.55m) from the screen.

How to make a folding screen
A typical screen can easily be made by ordering a white roller blind or by buying a roller blind kit. The stand can be bought from any photographic supply shop and Hey presto! Make sure the size of the screen you make is compatible with the size of lens in your projector.

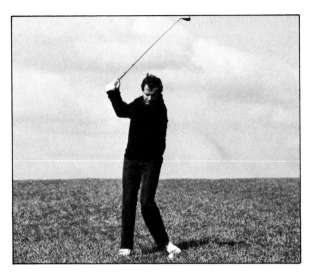

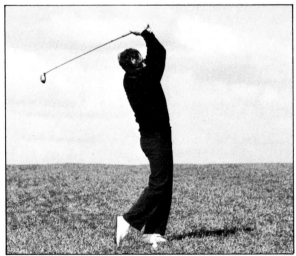

Making a flicker book

A flicker book is a series of pictures in sequence, which when bound together give the impression of movement. Keep the light soft and consistent if shooting indoors. Use a tripod and cable release. Shoot the sequence a number of times – it is easier to sort out continuous action from them at a later date. Make contact strips twice the size, cut out and bind together with plastic or brass nuts and bolts.

Recording your neighbourhood

As you grow older you will notice immense changes in your neighbourhood over the years. Now is the time to start recording on film any potential changes around you – a building being demolished, a new road being built, a visit by famous people. It will be a fascinating project which will be of considerable importance to the history of your town.

What is film?

Using light to make a permanent image on film was not possible until the 18th century. Scientists found that silver will form tiny grains of black when exposed to light.

Modern film still uses silver or more usually a mixture of silver and halogen (either bromide, chlorine, iodine or fluorine), which enhances the black, negative-forming properties of silver. The silver particles exposed to light entering the camera turn black when developed; these will be the light parts of the photograph. The silver particles unaffected by the light are removed during development, leaving a clean film base; these will be the dark areas of the photograph. At the printing stage light from the enlarger will shine through the clear film base and leave a dark image except where it is obstructed by the black silver particles where it will leave a light image. All tonal qualities on a finished photograph are a variation of these two extremes. The physical characteristics of this process are obvious: if you look at an enlargement of a photograph, it will look "grainy" – you can actually see under a magnifying glass the small black grains of silver which make-up the photographic image.

Emulsion

Tri-acetate film base

Anti-curl backing

How film is made
Black and white negative film and black and white photographic paper are made in almost the same way, the major difference being that negative film is coated transparent plastic whilst photographic paper is coated paper!

Silver halides are mixed in complete darkness with liquid gelatin. The mixture is then heated for several hours, which increases the sensitivity to light and helps reduce contrast.

It is then allowed to cool, shredded and washed in cold water, heated again and minute traces of a special dye added to give even more sensitivity to light. The mixture is now coated with a film or paper, allowed to cool and dry and then cut up into standard sizes.

A number of systems are used to identify the light-sensitivity of film.

The faster the film, the higher the number. Faster means the film needs less light to be able to register a photographic image.

Film Speed ISO (ASA)	DIN	Picture conditions cloudy/bright
25–32	16	1/125 f4
64	19	1/125 f 5.6
100 (colour neg)	22	1/125 f8
125		
200 (colour neg)	24	1/250 f8
200		
400 (colour neg)		
400	27	1/250 f11
1000 (colour neg)	31	1/250 f16

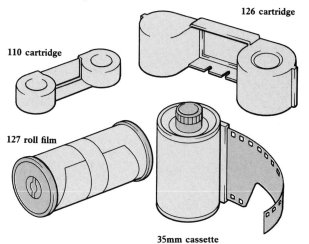

126 cartridge

110 cartridge

127 roll film

35mm cassette

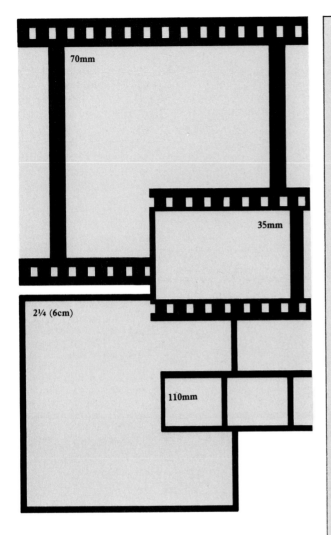

The most popular film is 35mm. It comes in plastic cassettes of 24 or 36 exposure lengths. 110 and 126 films come in plastic cartridges which are either broken open or put directly into the camera. They usually come in only 12 or 24 exposure lengths. One of the most popular roll films is 120. 127 roll film is smaller, giving a negative format 42 × 42mm. For the serious photographer 70mm and 2¼ film is available for twin-lens reflex cameras.

Colour films

White light is the source of all colour. Pass a beam of white light through a glass prism and the white light will split into its component colours. The colours shown will be the visual spectrum and they will range from deep blue to deep red.

Objects appear in certain colours because they reflect the light of some wavelengths and absorb all the colour.

White light has three main primary colours, blue red and green. If you were to shine beams of blue, red and green light onto a white surface, you would see white light where the colours overlap. Take one of the colours away and the reflected light would be different, for example red plus green would appear as yellow.

A colour film is made up of three layers of emulsion coated onto a plastic film base. Each layer of emulsion will respond to a different primary colour: the top layer records blue, the middle layer records green and the bottom layer records red. There are two main types of colour film; one is colour negative, the other is colour transparency film.

Colour negative film consists of three primary colour-sensitive layers.

Blue light is recorded on the top layer, green light on the middle layer and red light on the bottom layer. Yellow light, for instance, being a mixture of green and red, would be recorded on both the middle and bottom layers.

The action of light also forms a black image on all three layers. Colour negative film is used to produce colour paper photographs.

Colour transparency film is sometimes called "reversal" because the colour image must be reversed to restore the original colours of the scene. Transparency film must be used in the correct light for which it was designed: tungsten, daylight or photoflood.

Colour problems on the film cannot be altered during developing, as is possible with colour negative film. This is why exposure is very important. If in any doubt, bracket your picture. Colour transparency film is usually viewed as colour transparencies. It is possible to get colour prints made, but these tend to be expensive.

What is film?/2

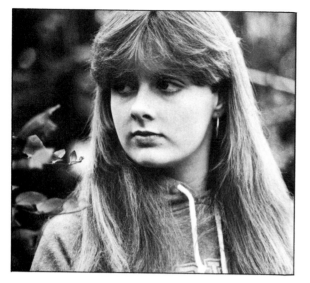

The four main types of black and white film are illustrated here. Each has a different ASA rating. All the camera shots were taken with a Nikon EM automatic with a 135mm lens set at f4.

The first picture taken with Pan-F (50 ASA) shows the fine grain available with this film. A low ASA number indicates that the silver halide grains are very small.

Medium-grained film, (above) Plus-X (125 ASA). Skin tones are a little coarser, but this is a good middle-of-the-range film, which will give greater exposure variations than other films. Ideal for studio work, and for enlargements.

Tri-x (400 ASA) fast film was used in the picture above. Grain is becoming more apparent. If you want to make enlargements from negatives, it will not be possible to enlarge more than eight times without loss of picture quality. This is the film to use if you need fast shutter speeds to "freeze" moving subjects.

Tri-x (uprated to 1600 ASA).
This sort of film has a pronounced grain which can be used to create a powerful moody atmosphere. Uprating means boosting development (*see* Darkroom). This film must be loaded into the camera indoors. An ideal film for taking pictures where there is very little light, e.g. portraits with candles.

Auto screen film
This is a litho film which has a special screen, giving an image made up of tiny dots. These can be used as line artwork in magazines.

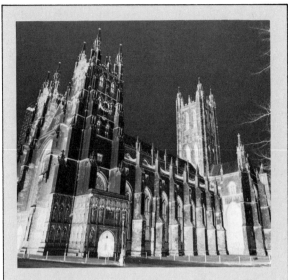

Infra-red film
An ideal film for ghostly effects; take a picture in daylight and green trees appear white, blue sky appears black. You will need to order this film in advance and use with an infra-red transmitting filter, but the effects are amazing.

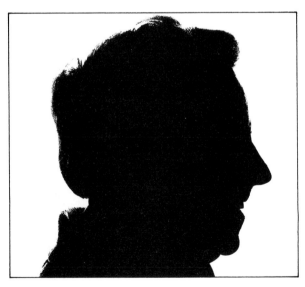

Line film
This film is ideal for taking photographs which need a dramatic solid black image. Obvious uses would be silhouettes and patterns of objects. It is also used to copy a normal photograph if you want a black line drawing.

X-ray film
Another film to be ordered in advance, it usually comes as sheet film. To take the picture above the camera was placed over a sheet of X-ray film, which was backed by a sheet of lead. An X-ray tube was placed overhead and switched on. X-ray film was developed with a high activity black and white developer.

The darkroom

Designing the darkroom

Too few amateur photographers have access to a permanent darkroom. Most borrow a room for a few hours and then have to give it back. The best room of all to borrow is the bathroom, as most of the facilities you need are already there. You will have hot and cold running water, sinks, ventilation and easy to clean surfaces. Remember always to leave the room as you found it!

You can quite easily use the bathroom to develop black and white film. You have to do this in complete darkness, so you will need light-tight curtains or a blind. Of course, the best time to do this is at night! It is a good idea to construct a table top that fits over the bath, put a lip around it and drill drain holes. All spilled chemicals will then find their way down to the bath. Keep a few inches of water in the bath and the chemicals will be diluted.

Making a room light-proof

All darkrooms need to be completely light-proof. The test is not if the room looks dark when you turn off the lights, but whether it is still dark ten minutes later. In a borrowed room windows can be blacked out with a ready-made frame made from light timber and black plastic sheeting. Use a floor mat to stop

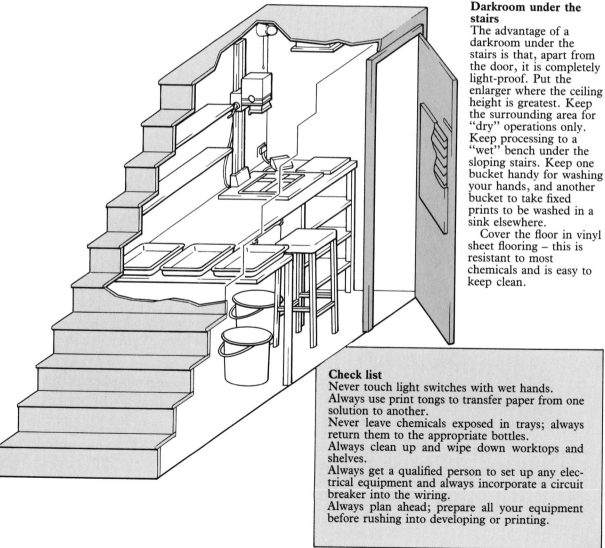

Darkroom under the stairs
The advantage of a darkroom under the stairs is that, apart from the door, it is completely light-proof. Put the enlarger where the ceiling height is greatest. Keep the surrounding area for "dry" operations only. Keep processing to a "wet" bench under the sloping stairs. Keep one bucket handy for washing your hands, and another bucket to take fixed prints to be washed in a sink elsewhere.

Cover the floor in vinyl sheet flooring – this is resistant to most chemicals and is easy to keep clean.

Check list
Never touch light switches with wet hands.
Always use print tongs to transfer paper from one solution to another.
Never leave chemicals exposed in trays; always return them to the appropriate bottles.
Always clean up and wipe down worktops and shelves.
Always get a qualified person to set up any electrical equipment and always incorporate a circuit breaker into the wiring.
Always plan ahead; prepare all your equipment before rushing into developing or printing.

leaks around a door; if the light still comes through, hang a black curtain over the door, and don't forget to stop up keyholes.

Adding photographic accessories

If you are using a bathroom, construct a strong table to fit over a substantial bench. Make sure you have separate wet and dry areas in your darkroom. The wet area is for developing and the dry area will have the enlarger, and printing paper.

You will need a supply of electricity for the enlarger. If using a bathroom, a trailing lead will be necessary. ALWAYS use a circuit breaker; electricity and water don't mix. A circuit breaker reacts to a potentially dangerous situation and could save you from a nasty electric shock. Use a sign on the outside of the door to warn people you are printing – never lock the door. You will need a safelight; it is possible to obtain one which will fit over the existing light – if not the bulb can be changed.

Arrange that you have a "wet" and a "dry" working area; make sure you have sufficient air flow through a ventilation system.

Make sure the floor covering is resistant to chemicals.

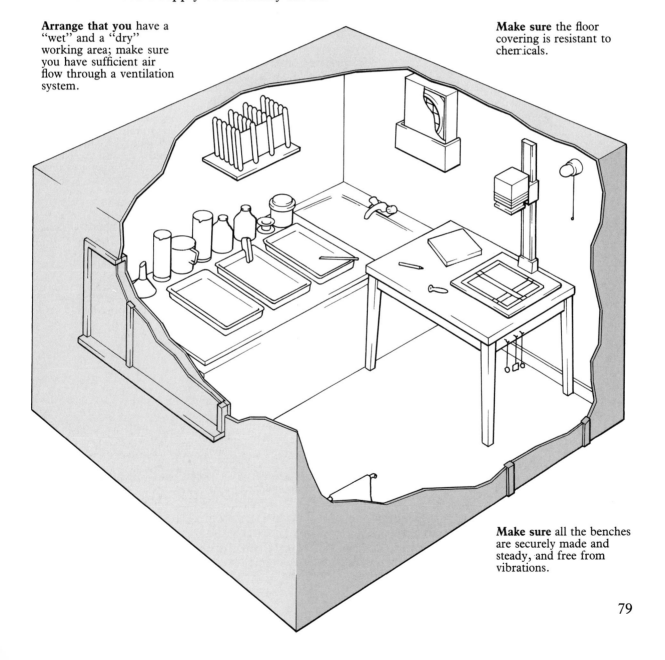

Make sure all the benches are securely made and steady, and free from vibrations.

Developing film

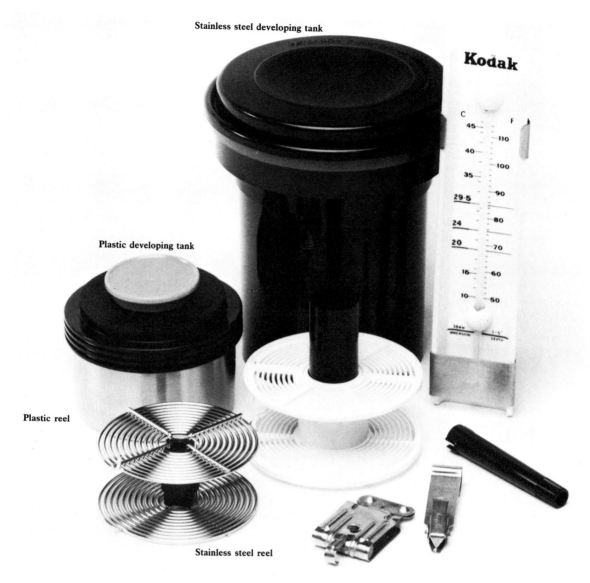

Stainless steel developing tank

Plastic developing tank

Plastic reel

Stainless steel reel

Black and white film can be processed at home in a very basic darkroom. Read the manufacturer's instructions carefully; some chemicals can be used more than once, but don't try to save money by using them more often than is recommended.

Always mark on the bottle how many times you have used them.

Once you have loaded the light-tight developing tank, all developing can be carried out with the light on. The developing tank is designed to accept the spiral reel upon which the film is wound. This leaves plenty of room for the processing liquids to circulate and develop the film evenly.

Once the reel is loaded with the film, placed inside the container and the lid put on developing solutions can be poured into the light-tight hole in the lid.

Make sure you keep "wet" and "dry" areas separate. Load the reel away from any wet areas and make sure your hands are dry too.

The processing tank can be of stainless steel or plastic construction: plastic reels can be altered to take different types of film, but stainless steel tanks and reels are more hard wearing and usually more expensive.

Make sure you wash out after use.

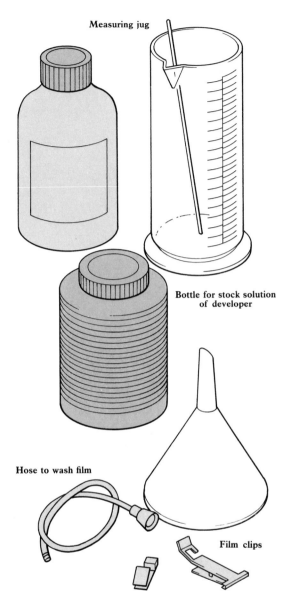

Measuring jug

Bottle for stock solution
of developer

Hose to wash film

Film clips

You will need various pieces of equipment to develop your film, apart from a developing tank. The process of development must be carried out in the dark. You will need three measures, each holding sufficient to fill the developing tank (about 300 cubic centimetres). Clear plastic is the safest and the easiest to use. Mark each measure "D.F." and "S" for developer, "Stop bath" and "Fixer". You will need a funnel to return solutions to their bottles, film clips for hanging up developed film and a short plastic hose which will connect directly with the developing tank for washing the developed film.

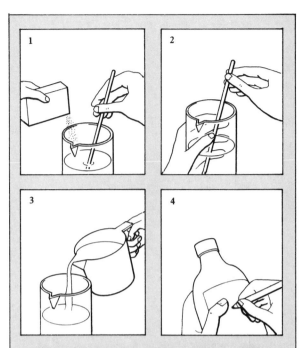

1 2 3 4

The secret of successful processing is to be tidy and to follow a set routine. Don't try new developer until you are quite familiar with the developer you have already. Developing negatives shouldn't make a mess, but if you haven't got a darkroom, work in the bath in the bathroom, but make sure you clean it out thoroughly afterwards.

Processing chemicals are bought as concentrated solutions or powers. Prepare stock solutions exactly to the maker's instructions (see above). 1. Use warm water 68°F (20°C). Pour the dry powder slowly into the warm water, stirring all the time. 2. Keep the chemical in solution all the time; don't allow it to froth or settle on the bottom. 3. Once the solution is completely mixed, add the next component and top up to the required amount with warm water. 4. Use a dark storage bottle slightly larger than the quantity of solution mixed. Mark the label with the name of the developer and the date mixed. Allow the solution to settle and cool and don't use for at least ten hours.

Choice of developer.

There are many different developers designed to produce different results, but they fall into four main groups. The standard group is characterized by two old favourites: Kodak D 76 or Ilfor IDII. The fine grain group produces negatives with fine grain, thereby giving fine detail.

The third group is high definition. The developers in this group, produce not quite as fine a grain as fine grain developers, but they do create an illusion of sharpness by what is termed the "edge effect" – a build-up on the division between two tones. The last group is "speed increasing". This allows the film to be exposed at a higher ASA speed than normal; useful for sports pictures on dull days.

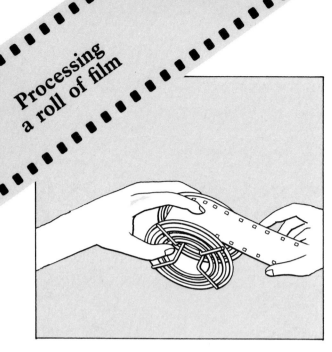

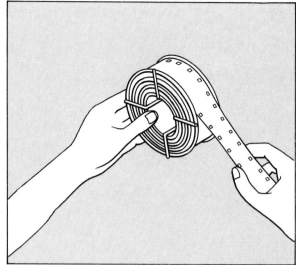

Before working in the dark, try a dummy run with a film cassette in daylight. When you are happy with the technique, try it for real.
Take the reel out of the developing tank, and if necessary adjust to fit the size of film you are developing.
Trim the end of the film square with a pair of scissors. Now switch off the light, lever off the tip of the film cassette with a bottle opener. Handle the film very carefully by the edges and feed it into the reel, following the natural curve of the film.
2. Bow the film slightly between thumb and index finger, rotate the reel in your other hand and pull the film slowly but firmly out of the cassette and onto the reel.

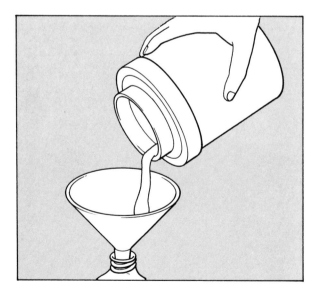

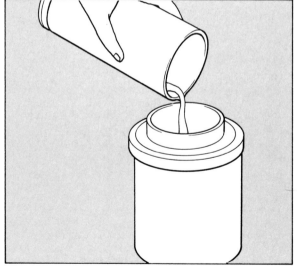

5. Ten seconds before the end of the time recommended by the developer instructions pour the solution back into the storage bottle, using a funnel.
Now pour in the stop bath solution, agitate and leave for one minute. After a minute, pour stop bath out of the developing tank and back into the storage bottle, using a funnel.

6. Pour the measured amount of fixer into the tank. Agitate for the first 15 seconds, and then again for 15 seconds of every minute. After four or five minutes remove the lid and examine the film. If it shows any milkiness replace the lid and continue fixing for another 2 or 3 minutes. Having fixed the film, return the fixer to its bottle.

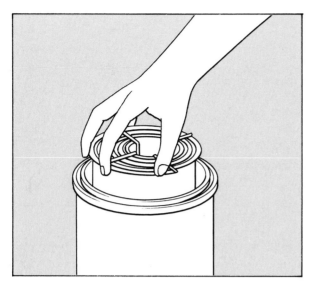

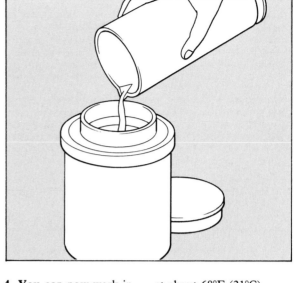

3. When the end of the film is reached, cut loose from the cassette and wind the remainder of the film onto the reel. Place the reel carefully into the developing tank. Close the lid tightly and switch on the light. Do not take the lid off until the film is fixed. Chemicals are poured in and out through a light-tight hole in the lid.

4. You can now work in ordinary light. Have all your solutions prepared at the correct 68°F (20°C) temperature. A good way to do this is to stand the measures of developer and fix in a dish containing a couple of inches of water at about 68°F (21°C). Now remove the small lid at the top of the developing tank and pour in the developer, then tap the tank to dislodge air bubbles and start the timer. Agitate the tank at intervals.

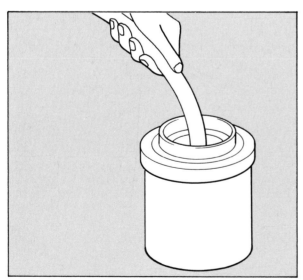

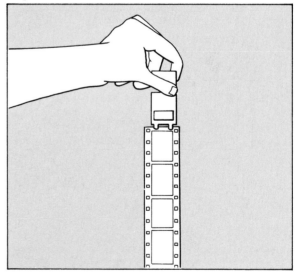

7. Place the developing tank containing the film into a sink and run cold (but not too cold) water into it, using a short piece of clear plastic hose. Continue washing the film gently for 30 minutes. After washing add a couple of drops of wetting agent to the remaining water in the tank, swill about and pour out the remaining water.

8. Attach a film clip to the end of the film and gently pull out the whole film. Attach a film clip to the other end to prevent the film from curling up. Hang the film in a dry, dust-free area overnight. Clean up and wash out all containers. Note that all chemicals poured down the sink *must* be diluted and washed away with copious amounts of water, as they can be very corrosive!

Enlarging and developing

The most important thing to remember when buying an enlarger is to make sure that it is suitable for the film size you use in your camera. If you are going to use more than one film size, make sure the enlarger you are going to buy is capable of accepting negative holders for the different sizes.

Choose an enlarger with a long, rigid column, as this will allow you to produce not only giant enlargements, but also selective enlargements of a small part of the original negative.
Make sure the enlarger gives you even illumination at all sizes of enlargement. Ensure also that the lens gives

sharpness over the entire picture area. It is useful if the head of the enlarger can be turned around, so that giant enlargements can be made against a wall (*see* pages 98–99).

Contact printing

1. Raise and focus the enlarger until light covers an area 210 × 270mm stop down to f8.

2. Swing the red safelight filter over the lens.

3. Lay out a sheet of bromide paper, shiny side up, in the area of the red light; place strips of exposed film in rows, emulsion (dull) side down; place a sheet of unscratched glass over the negatives and bromide paper, taking care not to leave any finger marks.

4. Remove the red safety filter away from the lens and expose for 7½ seconds. Experience will tell you if this is too long or too short. To develop the print, you will need the three different chemicals, print developer, stop bath and fixer. Mix these according to the manufacturer's instructions and warm to 68°F (20°C). In the darkroom, mix diluted solutions and pour into marked dishes.

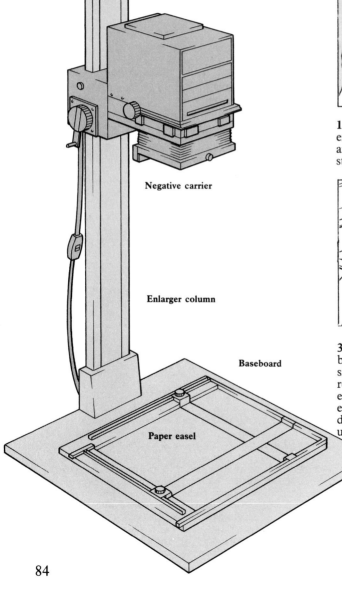

Negative carrier

Enlarger column

Baseboard

Paper easel

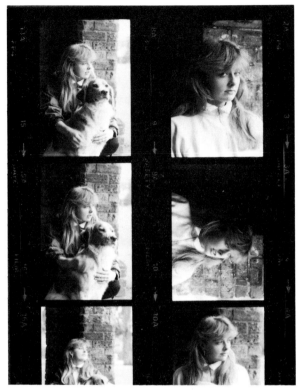

5. Slide exposed paper, shiny side down, into the developer; rock the dish for 20 seconds, turn the paper over and continue rocking for the recommended developing time.

6. Put it into the stop bath for 15 seconds.

Transfer to fixer for 2 minutes, then wash.

Photographic paper

For the photographer working in black and white, attention to detail is just as important in the dark room as it is behind the camera. Once a contact print has been made, a choice of negative suitable for enlargement can be made. A choice of printing paper is now necessary; choosing the correct printing paper is as important as choosing the correct film.

Bromide paper is used for making prints. This is a paper coated with an emulsion containing silver bromide.

Bromide paper comes in five grades. Normal range negatives can use grade 2 or 3; the other grades can be used to enhance an otherwise poor negative; grades 4 or 5 are high-contrast and can be used with great effect on silhouette-type subjects. Grade 1, on the other hand, can be used to reduce the contrast.

Bromide paper can be supplied in various finishes: "velvet stipple", "silk", "semi-matt", "rough luster" etc. It is better to start with grade 2 glossy. Get used to this paper first, then try others.
Bromide paper also comes in various weights. It is better to go for a "double weight" if printing large prints, as this will help prevent cockling and creasing. "Paper" bromide is made up of layers of paper, borgta, emulsion and supercoat (above). It requires a long washing time to remove chemicals from the paper base. It also takes much longer to dry then resin-coated paper (above top). This is a thin-base sandwich of paper, coated on both sides with resin and topped with emulsion and super-coat. This prevents the paper from absorbing chemicals so that washing and drying times are reduced. The supercoating and anti-static backing produce a high gloss without glazing and the paper dries flatter because there is no stretch as there is with normal papers.

Choosing the best negative

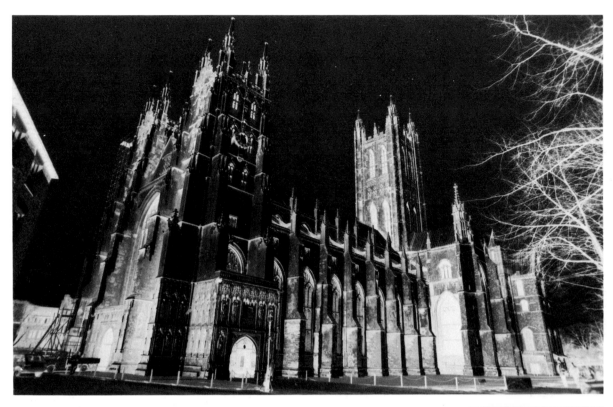

Choosing the best negative

The most important step in developing and printing is to produce a good negative. It should have plenty of detail in the highlights and shadows. To achieve this is simple: you need correct exposure in the camera and the correct developing time in the darkroom.

It is important to evolve a system which is right for you. Stick to one type of film and one type of developer, build on your experience of these two, and you won't go far wrong.

Having chosen the negative you wish to enlarge, check it over for fingerprints, dust and fluff. If necessary dust it with an anti-static cloth. Make sure the picture has sufficient detail in both the shadows and highlights.

Place flat in the negative holder, switch on the enlarger and, with the lens at full aperture, check that the negative image is sharp.

Look carefully at the image. Note that any details in the cathedral doors will be lost; also, without the use of a red filter, the sky and clouds behind the cathedral will be non-existent and the sky areas will print as white paper. Detailing on the stone work is good, with light and dark shadows, and should print well (*see* pages 90–91).

For the three portraits of the girl opposite we show two variations on straight printing and the results. The top portrait (opposite page) is over-exposed and under-developed. Shadow detail is heightened and delicate highlight areas are destroyed, printing only as a uniformily grey background.

The bottom portrait of the girl is under-exposed and over-developed. All details in the shadows have darkened. The overall effect is a much darker portrait with important detail lost. In the small portrait (above right) with normal exposure and normal development, all detail is correctly exposed, highlights are correct and not burnt out The result is a much more balanced photograph.

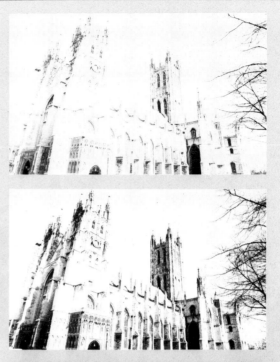

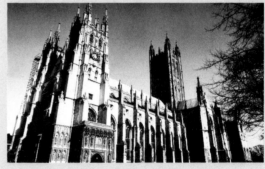

After exposing a bromide printing paper to the negative the paper will appear absolutely blank, but once immersed in the developer bath the transformation starts. The darkest shadows appear as grey tones which gradually become darker, as other parts of the picture develop.

At the end of the development stage the picture is fully developed, all areas appearing as they should. Now is the time to fix the print. This stops development, and removes all remaining silver halides by a complex chemical process.

Washing removes all remaining halides and chemicals leaving the print with a permanent black and white image.

Using a test strip

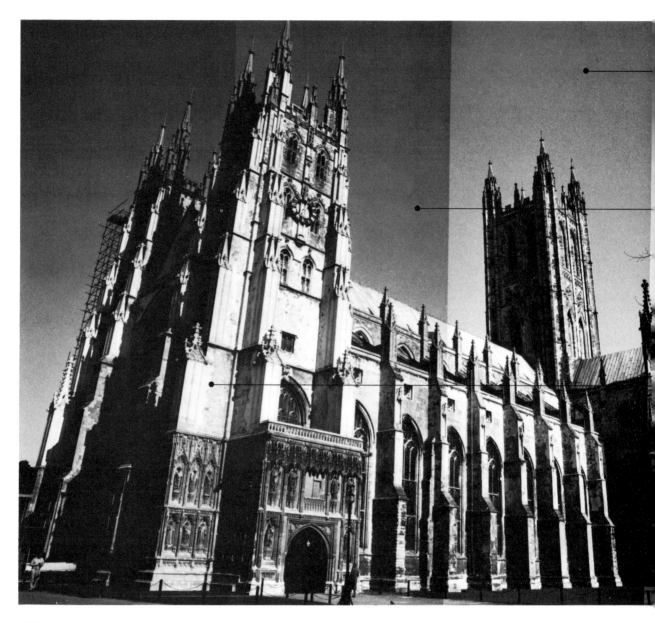

Making a test strip
To work out the correct
exposure time for a print
from a negative you need
to make a test strip of the
chosen negative.
Place the negative shiny
side up into the negative
carrier of the enlarger and
place in enlarger. Set at
f8 and adjust the enlarger
until you have the correct
size image on the
baseboard. Make sure the

image is sharp and if
necessary correct the
image size after focusing.
Place a sheet of grade 2
paper in the easel, cover
with a sheet of paper,
except for a 1″ strip, and
expose for 5 seconds.
Move the card at 5 second
intervals so that the strips
of the bromide paper are
exposed for 5, 10, 15, 20
and 25 seconds.
Develop the test strip as

shown on page 85.
Examine the print and
decide which exposure
time gives the best result.
If the result is too dark
set the enlarger lens at
f16. If the result is too
light, double the exposure
time to 10, 20, 30, 40
seconds.

5 seconds exposure
Picture is too light, no detail in shadows, complete loss of sky.

15 seconds exposure
Shadows have a good rich black, all details on stonework are correctly exposed sky has a light tint which enhances stonework.

20 seconds exposure
Dark areas in the stonework are now too heavy, all details have merged together, sky is darkening up.

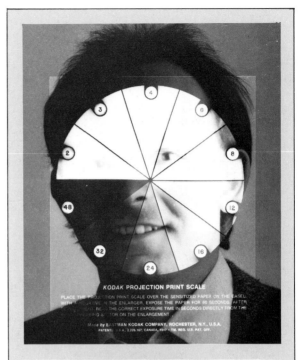

KODAK PROJECTION PRINT SCALE

PLACE THE PROJECTION PRINT SCALE OVER THE SENSITIZED PAPER ON THE EASEL WITH A NEGATIVE IN THE ENLARGER. EXPOSE THE PAPER FOR 60 SECONDS. AFTER DEVELOPMENT READ THE CORRECT EXPOSURE TIME IN SECONDS DIRECTLY FROM THE APPEARING SECTOR ON THE ENLARGEMENT.

Made by EASTMAN KODAK COMPANY, ROCHESTER, N.Y., U.S.A.
PATENT: U.S.A. 2,226,167, CANADA, 1917 • TM. REG. U.S. PAT. OFF.

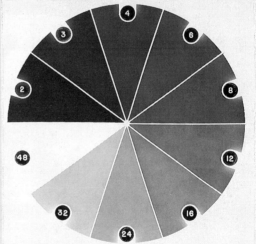

Grey scale
Its possible to buy a piece of film divided up into segments ranging from clear film through seven or eight gradually darker tinted segments to almost black.
Expose for 60 seconds and develop. Inspect the image and select the sector that appears to have the correct density; the number on the rim of the sector is the starting exposure time in seconds. Now without the scale, make an exposure at this time setting on another sheet of bromide.

Printing

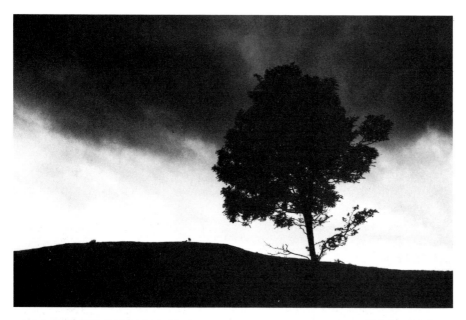

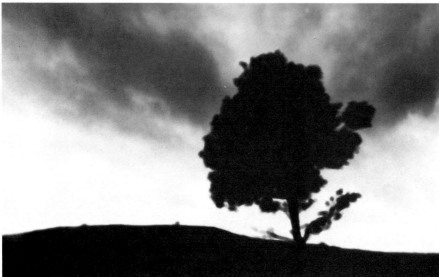

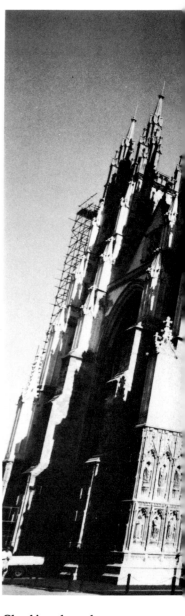

Out of focus print
Some negatives have detail which must be kept in focus, whereas other negatives can be enhanced by being out of focus. If it is necessary to have a print pin-sharp it is worth buying a focus-finder or magnifier which will reflect on a chosen section of the negative. By focusing on this, maximum sharpness is assured.

Checking the enlargement
Is it too dark or too light? Would it look better on a harder or softer paper? Is it out of focus? Are there any white specks and marks? All these questions, and others, will be answered with experience. Careful use of a test strip will tell you whether it is too dark or too light. Try printing on a harder or softer paper.

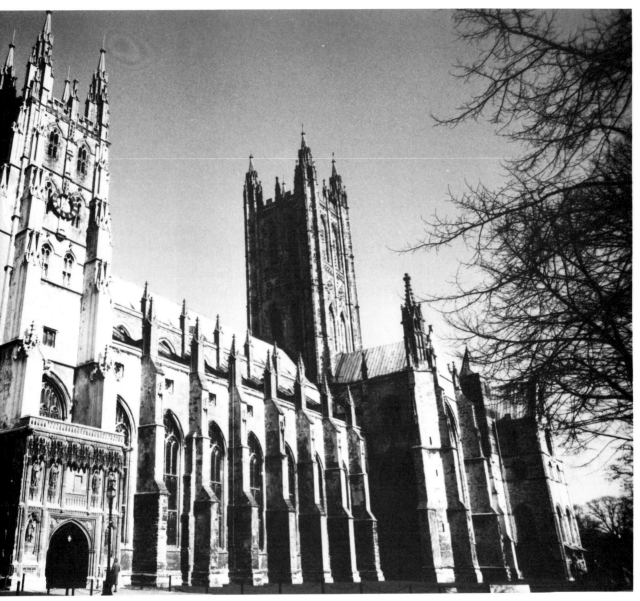

The easel

Get used to the different types and settle down with what you prefer. If the print is out of focus, is it the negative or is it the enlarger that is at fault. Look at the corners as well as the centre – if only the corners are out of focus the enlarger could well be to blame.

White specks are caused by dust: make sure both the bromide paper and negative are completely clear of dust. Check the negative by examining the image projected onto the easel. Move the negative carrier; if the specks move, they are on the negative. If they don't, they are either on the lens of the enlarger or on the bromide paper.

Using a 'dodger'

"Dodging" and "Printing in."

Local areas of a print can be lightened or darkened during printing by exposing isolated areas to more or less light. You can simply block off light with your hand, or use a piece of card with a hole in it to expose a detail to more light and consequently make it darker.

Make sure you constantly agitate it or the edge will show.

In the picture (above) detail is missing through the arch, although it is present on the negative. In the picture (opposite top) the detail is correctly shown through the arch, but now the wall is over-exposed and too dark. In the picture (opposite bottom), by using a piece of card cut to the opening in the arch, the arch can be correctly exposed, then covered whilst more light is exposed through the negative to fill in the details previously lost through the arch.

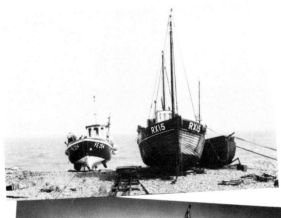

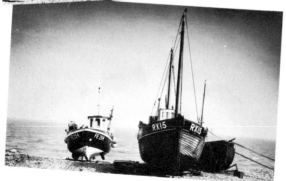

Improving prints

The fishing boats print (top left) was made on grade 3 paper. Although full of contrast, the sky has bleached out. To rectify this the bottom print was done on grade 1 paper. The print retains all the detail of the fishing boats as well as some grey tone in the sky.

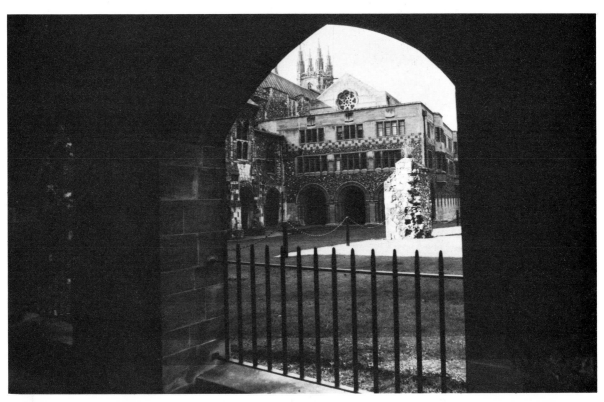

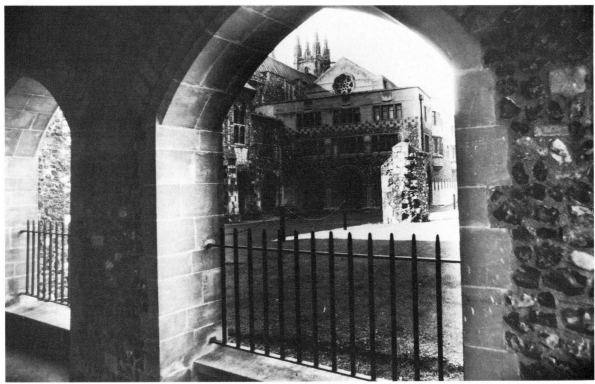

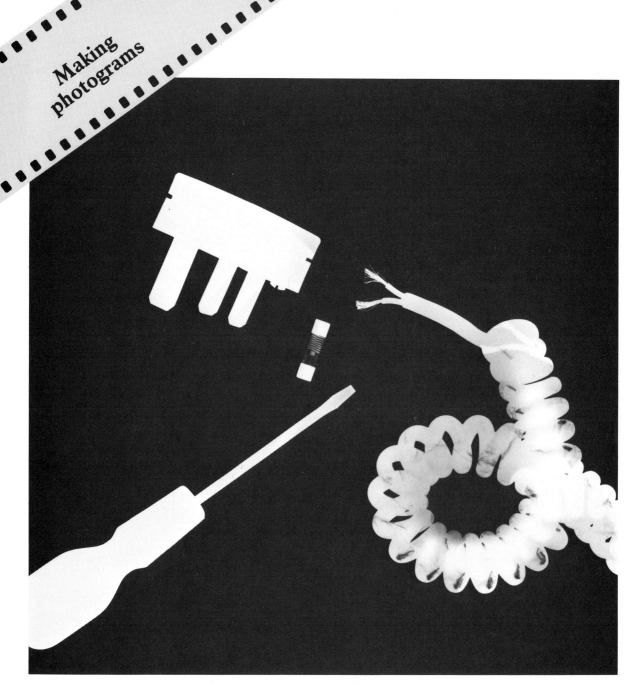

Photograms are pictures taken without a camera. You can use various objects to make interesting patterns.
In the darkroom, take the flex and screwdriver and place on a sheet of grade 3 bromide paper, expose for about ten seconds and then develop in the same way as you would a print, using developer, fixer and then washing.

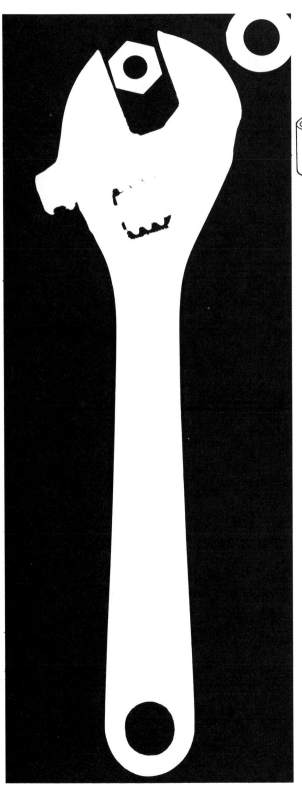

Washing prints is vital for their long term stability. Insufficient washing means that sooner or later the prints will stain and the image will begin to disappear.

Ideally prints should be washed in a tank where the water is constantly being changed. If this isn't feasable, make sure you change the water every five minutes for about an hour for paper bromides. For resin-coated bromides, two changes in ten minutes will be more than sufficient.

Whilst prints are being washed, make sure the prints, don't stick together whilst floating on the surface.

Once the prints are fully washed they are ready for drying.

Resin-coated paper can dry naturally with a glaze, but convential paper-based prints need to be glazed by squeezing them, face down, onto a polished chrome surface (above left) and then holding them in contact with a metal surface by means of a stretched cloth (above right) whilst the print drys.

Making photograms/2

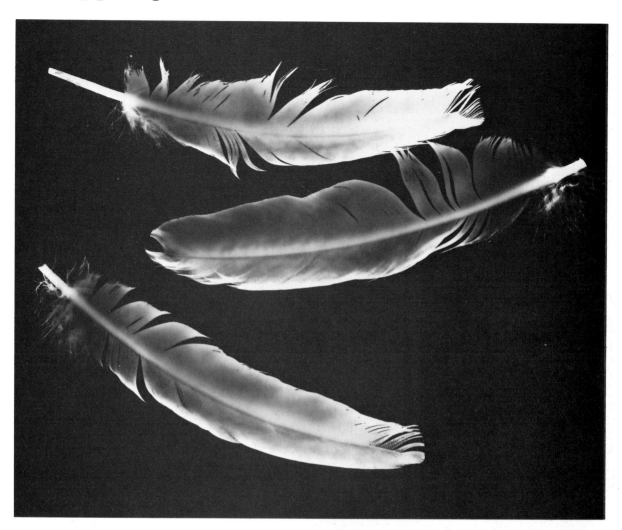

Explore the possibilities of photograms. After the initial excitement of creating photograms has worn off, think of ways in which you can use these pictures. The picture (far right) is from a photographic pressed-flower collection, whilst the screws and hinges are a cheap way of compiling a catalogue of artifacts.

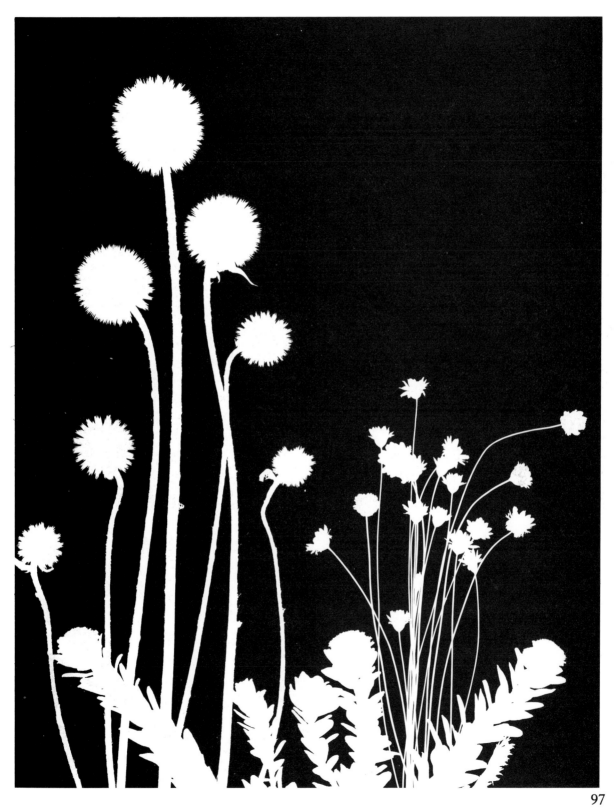

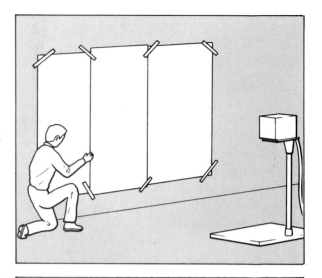

Giant enlargements

An original way to decorate a bedroom or playroom is to decorate one wall with a giant enlargement; it can cover a wall, door or even the ceiling! To get the enlargement sufficiently large, your enlarger must be able to focus on a wall several metres away. Use resin-coated paper in the largest size you can afford – it is possible to buy it in rolls. To start you need to tape up sufficient paper (under red light conditions) to cover the area (see above right). Overlap the joints, they can be trimmed later. Expose a large test strip initially and dodge in if necessary during exposure.

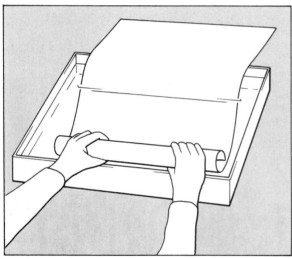

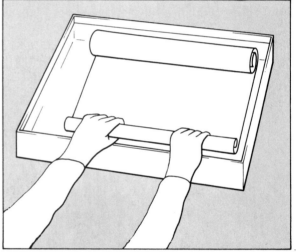

To give you more time to develop, dilute the developer by half and double the development time. Roll up the print, immerse it in the developer (above left) unroll and re-roll (above middle). Check the density of the photograph from time to time and when the print is fully developed lay out onto clean, absorbent newspaper and leave to dry overnight.

Use ordinary wallpaper paste to glue it to the wall. Make sure you dry fit it first and trim any overlapping margins.

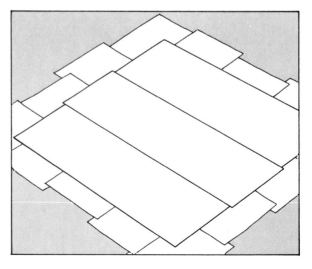

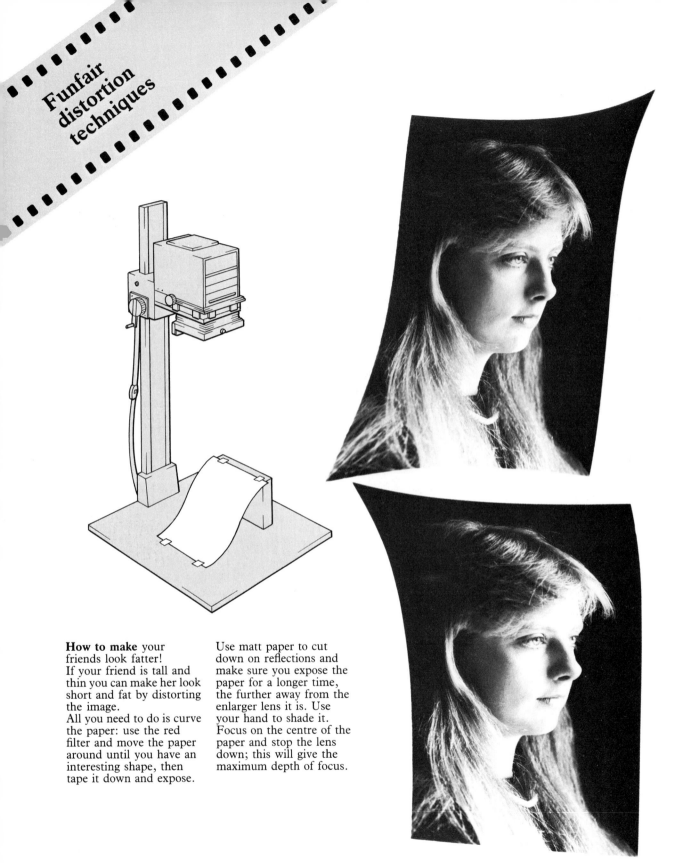

Funfair distortion techniques

How to make your friends look fatter!
If your friend is tall and thin you can make her look short and fat by distorting the image.
All you need to do is curve the paper: use the red filter and move the paper around until you have an interesting shape, then tape it down and expose.

Use matt paper to cut down on reflections and make sure you expose the paper for a longer time, the further away from the enlarger lens it is. Use your hand to shade it. Focus on the centre of the paper and stop the lens down; this will give the maximum depth of focus.

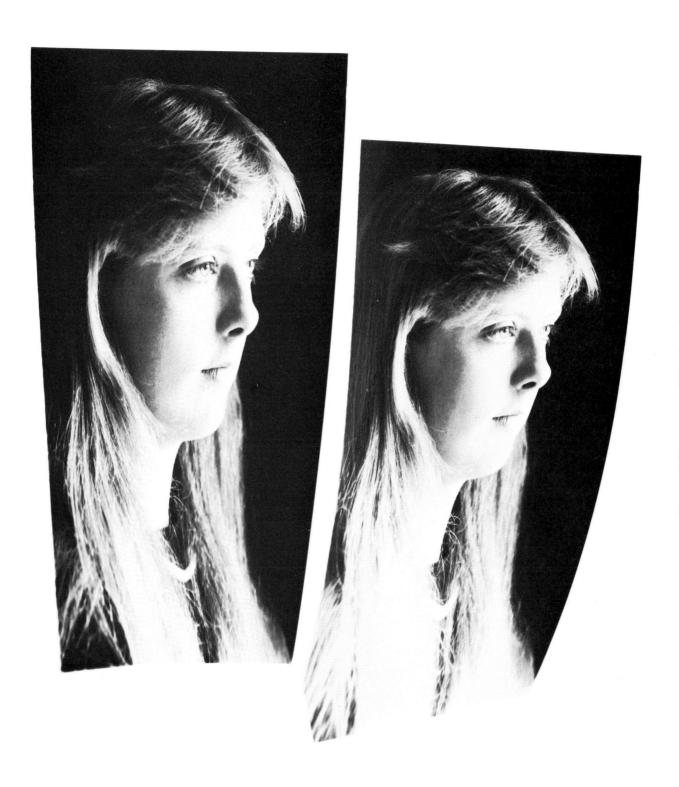

How to make old fashioned vignettes. There are two types of vignettes; with a white border (far right) and with a black border (bottom left). For the white border variety you need to make a "dodger" (a sheet of card with an ellipse cut into it). Expose through the cut hole and you will get a soft-edged picture, as far right. For the other type of vignette you need to reverse the process (right). Cut an ellipse, tape it to a wire, expose print normally but then re-expose without the negative. Move the cut-out slightly to get a blurred edge and the result will be as below.

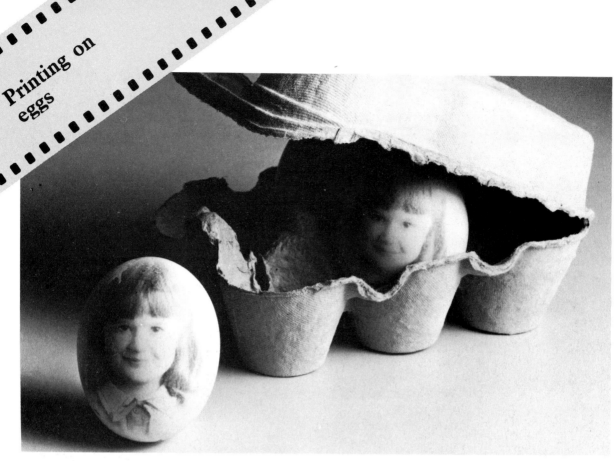

If you buy a bottle of photographic emulsion you can paint numerous objects – buttons, eggs, plates, glass, wood – and then print your own photo onto the surface. Although not cheap, it may be possible to persuade your art teacher or youth leader to buy a bottle as a group project. Make sure you follow the instructions on the bottle carefully. Expose and process in the normal way.

For the egg (illustrated above) make a balsa wood holder which can be stuck to the egg with glue. If you intend to keep the egg, blow the insides out after making a small hole at each end. Coat the clean and dry egg with the warmed emulsion. Make sure you have the red light on! Leave to dry and, still using the red filter, position the egg under the enlarger until you are happy with the image projected onto it. Immerse the egg into developer; when the image has fully developed, stop and fix in the normal way, wash, and leave to dry overnight. You now have egg all over a face!

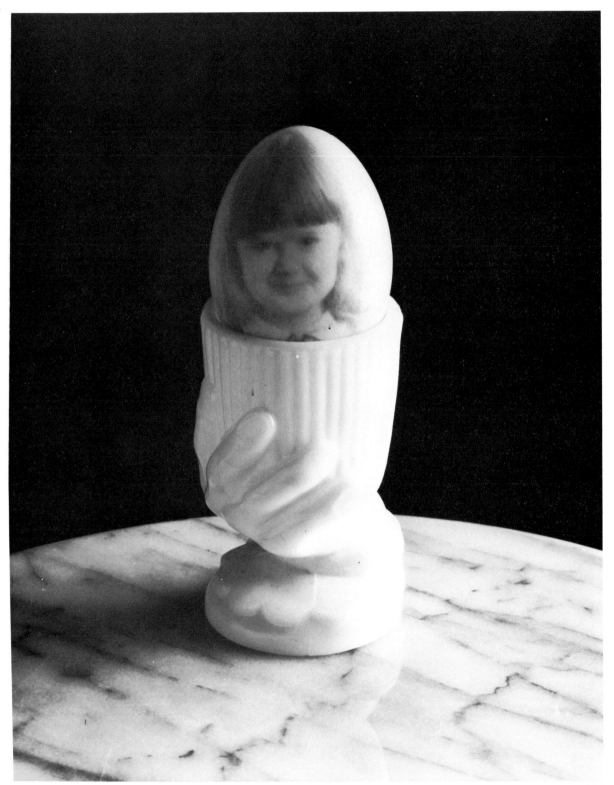

Making photo-montages

Great fun can be had with cutting, slicing and sticking together a sequence of photographs so as to make patterns and shapes.

Use a sharp craft knife and metal ruler. If you wish to cut out circles, use a compass with a cutting attachment. Glue onto a sheet of mounting board after arranging the shapes in the most exciting way.

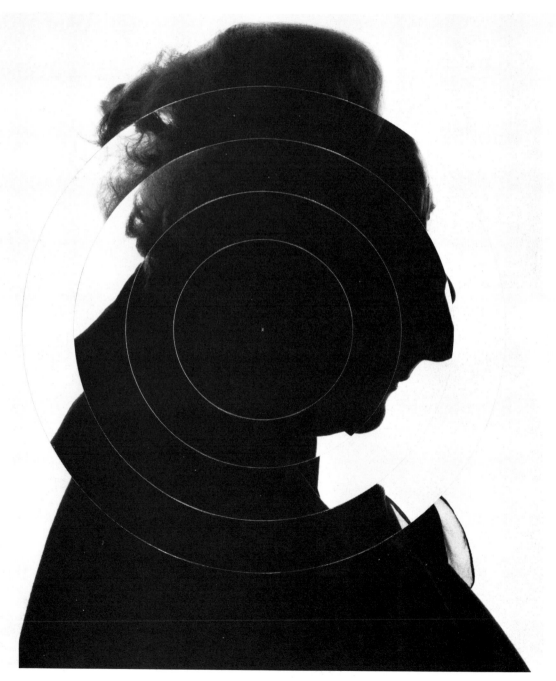

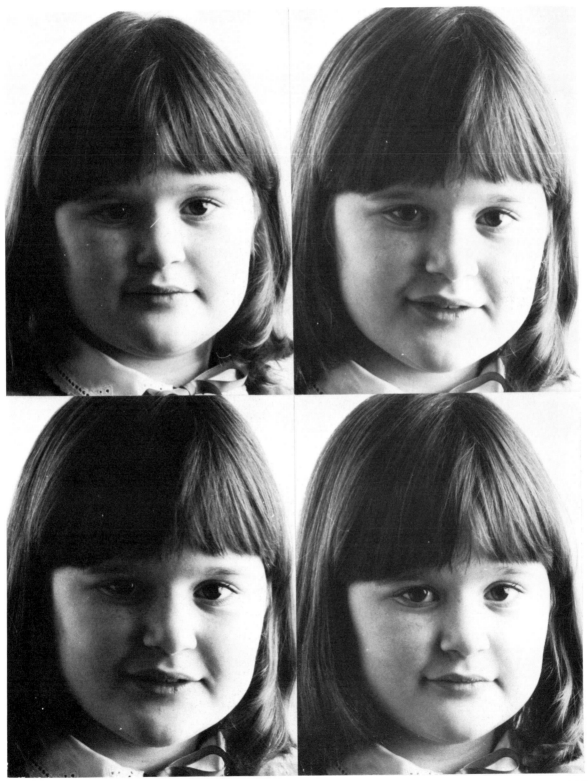

Glossary

Acetic acid A chemical used in stop baths to neutralize and stop development before prints of negatives are put in the fixer.

Agitation A means of constantly moving a print or negative so that fresh chemicals are kept in contact with the emulsion surface.

Air bubbles Bubbles of air which attach themselves to the emulsion and prevent development. Agitation is the method used to remove air bubbles during processing.

Air brushing Method of retouching photographic prints by the use of a fine high-pressure spray of ink. This method requires considerable practice and is not to be undertaken lightly.

Angle of reflection When light is reflected from a surface, the angle formed between it and the imaginary right angle to the object is called the angle of reflection.

Angle of view The largest angle possible between two rays of light passing through a lens which will give a photograph of acceptable quality.

Aperture A circular hole behind the lens of the camera which controls and regulates the amount of light passing through onto the photographic film. The size is controlled by the "f" number ring.

Aperture-priority camera A semi-automatic camera on which the photographer sets the "f" number (aperture) and the camera automatically sets the shutter speed. It is possible to override the system in a number of ways if necessary. One way is to "bracket": using the ASA film speed dial, set at a higher and then a lower film speed setting and you will get a "bracket" exposure setting.

ASA The letters stand for the *American Standards Association*, who have recommended a way of classifying film through a speed system. Film manufacturers rate their film in terms of its sensitivity to light, e.g. 200ASA, 400ASA, 1000ASA. The higher the number, the faster the speed of the film (i.e. the light sensitivity).

All ASA speeds are printed on the film cartridge and box.

Automatic lens A lens which stays at full aperture, whatever working aperture is set, until the picture is taken. This allows perfect focusing without affecting metered exposure through the lens.

Autowinder A camera which has the facility to wind the film on one frame each time the shutter is released.

Back projection A technique for producing outdoor scenes in the studio. An exterior photograph is projected onto a translucent screen to form a backdrop against which subjects can be photographed.

Barn doors Attachments for spot lamps and floodlights, used to control the direction and width of the light beam.

Bellows A light-tight folding sleeve between the lens and the camera, mainly used in close-up photography.

Bleaching A chemical process which converts the black silver image into a colourless image. It is the first step in sepia toning.

Bracketing The art of shooting a number of photographs of the same subject and viewpoint but at different exposures.

Bromide paper The paper-based light sensitive photographic paper used for printing photographs.

B Setting The symbol on the shutter setting ring denoting that the shutter will stay open while the shutter button remains depressed.

Burning in A method of controlling small areas of development during printing. The addition of small beams of controlled light through the use of fingers or a dodger, "burns in" more exposure during enlargement printing.

Bulk film With motor drive cameras it is cheaper to buy film in bulk.

Cable release A simple flexible cable used for firing the camera shutter. It prevents you from needing to touch the camera during long exposures and consequently reduces camera shake.

Camera obscura The earliest form of camera. In its most primitive form it consisted of a darkened room with a small hole in one wall; light rays would pass through a show on the opposite wall and invert an image of the scene outside. It was first described by Aristotle in the 4th century BC.

Cartridge A quick-loading film container, made of plastic and pre-loaded by the manufacturer.

Cassette A light-tight metal or plastic container holding 35mm film. The film needs to be loaded into the camera.

Centigrade A scale of temperature where 0 equals the freezing point of water and 100 equals its boiling point.

Circuit-breakers A device which protects you from electrocution if there is a surge of electricity.

Coated lens Lens with a coated glass surface, which reduces lens flare.

Complementary colours Two colours are complementary if, when added together, they make white.

Primary	Complementary
Blue	Yellow
Green	Magenta
Red	Cyan

Converging lens A lens which cause rays of light to converge to a point (*see* Convex lens).

Convex lens A lens which causes rays of light to converge to a point.

Daylight colour film A colour film to be used with a daylight light source.

Depth of field The distance between the nearest point and the farthest point which can be said to be in focus.

DIN Stands for *Deutsche Industrie Norm* and is a German system of rating film sensitivity to light. The system is being replaced by the ISO system.

Diverging lens A lens which causes light to bend away from a light source; a typical example is a concave lens.

"Dodging" A means of reducing the amount of light to a small area during exposure of the printing paper.

Drying marks Scum marks left on negatives and bromides by insufficient washing during processing.

Enlargement A print larger than the negative size.

Exposure meter An instrument for measuring the amount of light necessary for a photograph. The information is used to set shutter speed and aperture size.

Extension tubes Accessories used in close-up work to extend the film-lens distance; provides magnification over × 1.

Fahrenheit A scale of temperature named after its inventor, G. Fahrenheit. Freezing point is 32°F and boiling point is 212°F.

Filters Coloured gelatin or plastic disks which alter the quality of light passing through them.

Fixed focus Cheap cameras usually have this system, where the lens is fix-focused on a distance most suitable to the type of subject usually photographed.

Flare Light particles scattered throughout the lens and which appear on the photograph as distracting blobs of bright light.

Focusing A method of moving the lens to form a sharp image on the film.

Fogging Accidental exposure to light of film or printing paper; the result is a continuous grey tone over the picture.

Glaze A glossy surface on photographic prints which will enhance the deepest blacks of the image.

Grade Classification of photographic printing paper. Nos. 0 to 1 = soft, No. 2 = normal, No. 3 = hard, Nos. 4–5 = very hard.

Highlights The brightest areas of the photographic print, represented by dark areas on the negative.

Hypo The slang name for a fixer, derived from hyposulite of soda.

ISO *International Standardization Organization*; used instead of ASA or DIN to indicate film speeds.

Incident light The light falling onto a subject.

Incident light reading Measuring the light source; the exposure meter would be turned away from the subject and pointed towards the light source.

IR or R setting Marked in red on many camera lenses, it indicates the change of focus position necessary for infra-red photography.

I setting Usually found on cheap cameras, "I" stands for "instantaneous" and will give a speed of around 1/60 second.

Lenses Single or multiple collection of glass surfaces, all of which bend light. There are two types, convex which bends rays of light to converge to a point, and concave which causes rays of light to diverge from a point.

Lens hood An opaque tube, made of plastic or rubber which prevents unwanted light falling onto the lens and causing lens flare.

Lightbox A box equipped with fluorescent tubes balanced for white light and covered with a sheet of translucent plastic or glass. It is used for viewing negatives and transparencies.

Reflector A material from which light can be reflected onto the subject. Crumpled-up baking foil stuck to a sheet of cardboard is a useful accessory.

Safelight Most photographic materials are insensitive to certain colours, for example orthochromatic film is insensitive to red so can be handled safely in a red safelight. Check all manufacturers' specifications and make sure you have the correct one.

Shutter A mechanical device for controlling the amount of time that light is allowed into the camera.

Speed The sensitivity to light of photographic emulsions. Films are given ASA, ISO or DIN numbers, which denote speed.

Stopping down Reducing the size of the lens aperture and reducing the amount of light passing into the camera. It will also increase depth of field.

Test strip An exposure exercise in printing to work out the correct exposure required for a finished print.

Transparency A positive image on a film base called a "slide".

T Setting A camera shutter setting indicating "time" exposure; the shutter opens when the release is pressed and closes when pressed again.

TTL Through the lens metering measures light passing through the lens for automatic exposure.

Viewpoint The position of the photographer and camera in relation to the object to be photographed.

Washing Final part of processing which removes all unwanted chemicals from the emulsion.

Zoom lens An extremely useful lens with variable focus; you can literally "zoom in" on your subject without changing your own position.